A History of Boston's
Jewish North Shore

A History of Boston's
Jewish North Shore

Alan S. Pierce

On behalf of the
Jewish Historical Society
of the North Shore

Charleston London

THE
History
PRESS

Published by The History Press
Charleston, SC 29403
www.historypress.net

Front cover images: Top: A jubilant groom breaks the ceremonial glass after exchanging
vows. *Courtesy of Harold Summers Photography.*
Bottom: The Great Shofar Blowout. *Courtesy of Herb Goldberg.*
Back cover images: Top: Salem merchants and businessmen near the Salem Common.
Courtesy of Judy Simon Remis.
Adult Bat Mitzvah celebration. *Courtesy Jewish Journal of the North Shore.*

First published 2009

Manufactured in the United States

ISBN 978.1.59629.658.9

Library of Congress Cataloging-in-Publication Data

Pierce, Alan S.
A history of Boston's Jewish North Shore / Alan S. Pierce.
p. cm.
ISBN 978-1-59629-658-9
1. Jews--Massachusetts--Boston Region--History--20th century. 2. Jews--Massachusetts-
-Boston Region--History--21st century. 3. Jews--Massachusetts--Lynn--History. 4.
Jews--Massachusetts--Swampscott--History. 5. Jews--Massachusetts--Peabody--History.
6. Jews--Massachusetts--Salem--History. 7. Jews--Massachusetts--Beverly--History. 8.
Massacusetts--Ethnic relations. I. Title.
F73.9.J5P54 2009
974.4'5--dc22
2009015722

L'dor V'dor

From Generation to Generation

This book is lovingly dedicated and was expressly prepared for our children and our children's children.

CONTENTS

INTRODUCTION

The photographs are faded, the names are long forgotten; streets and buildings that once echoed with the sounds of life have vanished. It is easy to forget the past, easier still to ignore the simple fact that one day the fabric of our lives, our work, our dreams will become the threads of some distant history. But these are reasons to remember because somewhere amidst the fading images, forgotten names, vanishing streets, we find ourselves. And though it is easy to forget, we remember. Because in this book, a portrait of our community, we remind ourselves of not only who we were, but who we are.
—*Steve Cohen in* Reasons to Remember, *a documentary produced by the Lynn Arts Council and the Jewish Historical Society of the North Shore*

The Jewish Historical Society of the North Shore (JHSNS) was founded in 1977 with a mission to collect, preserve and display the tangible evidence of the Jewish presence on the North Shore of Boston. For over thirty years, JHSNS has strived to serve our community as a link to the past and a precious resource for future generations. We hope that this book serves to further that mission in an effective way.

Alan Pierce, president of the Jewish Historical Society of the North Shore, originated the idea of a new history of the North Shore's Jewish communities, one that would include more text than the society's previous publication, first published in 2003. He took the lead in organizing the committee, delegating the research, authoring some of the sections and cheering everyone on. Society members Edye Comins Baker, Helaine Roos Hazlett, Judy Simon Remis, Judy Axelrod Arnold, Ruth Kemelman Rooks and Elaine Hillson Federman researched and authored all or parts of the chapters. Barbara Tolpin Vinick was the overall editor.

INTRODUCTION

Chapters cover the cities of Lynn, Peabody, Salem and Beverly and the towns of Swampscott and Marblehead. These cities and towns comprise, for the most part, the archives of JHSNS. The book is a compilation of the histories of these communities from several sources—principally from the archives of JHSNS but also from material generously made available by the *Jewish Journal Boston North* and the many Jewish institutions that continue to serve the community spiritually and culturally. With over a century of Jewish life to cover with limited time and pages, we tried to mention as many people, businesses and Jewish institutions, past and present, as possible in order to capture the essence of our rich Jewish history. We realize, however, that although our intentions were to be inclusive, we may have left out some important elements of that history. Please forgive our lapses.

Over a century ago, Jews, primarily from eastern Europe, arrived in the major North Shore cities of Lynn, Peabody, Salem and Beverly. This led to the rapid development of urban Jewish neighborhoods and their sustaining institutions—synagogues and mutual aid societies. There soon followed Hebrew schools and community centers. These cohesive communities flourished through the first half of the twentieth century. After World War II, however, with postwar prosperity and the assimilation of second- and third-generation Jews, movement out of traditional Jewish neighborhoods was widespread. Many of Lynn's Jews moved to neighboring Swampscott and Marblehead. Rural farmlands of West Peabody gave rise to suburban subdivisions attracting Jews from downtown Peabody, as well as from the other Jewish strongholds of Chelsea, Revere, Winthrop, Malden and Everett.

Demographic shifts had a profound effect on the synagogues and community centers that had served the older cities so well. In the 1960s, the Lynn Jewish Community Center on Market Street relocated to Marblehead. Peabody's Hebrew Community Center closed in the early 1970s and was replaced by the North Suburban JCC in West Peabody. Shuls closed and newer, more modern temples were built in Marblehead, Swampscott and West Peabody. Beverly and Salem, in the latter half of the twentieth century, saw a decline in Jewish population with movement to outlying towns of Middleton, Danvers, Ipswich and Boxford, where land was less expensive and bigger homes could be built.

Today, demographic and social changes continue to place increasing tension on the institutions that have supported the Jewish community so well for so long. In Swampscott, Temple Israel and Temple Beth El merged into Congregation Shirat Hayam in 2005. Other synagogues are faced

with the challenges of diminishing membership, aging buildings and a population base more spread out—factors leading to the necessity of creative approaches to maintaining a sense of Jewish community. One thing seems clear: the twenty-first century will continue to challenge the area's Jews, as our ancestors were challenged over one hundred years ago. This book allows us to see and celebrate who we were and to inspire us to maintain our Jewish community. In all important ways, it is who we are.

LYNN

The city of Lynn, incorporated in 1631, is located thirteen miles north of Boston, along the coast. Long known as a major center of shoe manufacturing, Lynn fell into economic decline in the 1970s. Many of its Jewish neighborhoods have been replaced by neighborhoods of new immigrants with Hispanic and Southeast Asian roots. This chapter focuses on Jewish life in Lynn and the Jews in Lynn's shoe trade.

THE JEWS IN LYNN, A RETROSPECTIVE

Based on a 1986 monograph by the late Nathan Gass

A rural Yankee town in the early nineteenth century, Lynn had little fertile farmland. Its coastal waters, unlike those of neighboring Salem, provided a poor harbor for trade. As a result, Lynn had a small population and an industry limited to local handicrafts and cottage industries.

The first Jewish name to appear in a Lynn city directory is Simon J. Weinberg, who operated a dry goods store at 6 Market Street in 1856. Born in Poland thirty years earlier, Weinberg arrived in Lynn in 1855. He lived at

209 Washington Street with his wife, Hannah, and their children, Ezekiel, Fannie and Bertha. In addition to being, in all likelihood, the first Jewish resident, Weinberg proved to be among the most active. A kindly and gentle man, with little formal education but possessing a keen mind, he was a gifted leader who took charge of community activities for the twenty-five Jewish families who came to live in the city. His commitment to the small Jewish community made life more tolerable for those who followed. Recognized as the founder of the Lynn Jewish community, Weinberg saw the need for basic institutions that would ensure the survival of Jewish life in Lynn. In 1886, he helped organize the first Jewish communal organization, the Lynn Hebrew Benevolent Society, whose members carried out the basic responsibilities of a Jewish community—attending to the sick and burying the dead. Weinberg also founded the "Litvishe Shule," still in existence today as Congregation Ahabat Sholom, and became its first president.

Other early Jewish settlers lent a hand in the development of the community. Solomon Wyzanski arrived in Lynn in 1858 and opened a general store. Lewis Wolf, who came to Lynn in 1867, had a delicatessen. Ezekiel Borofsky arrived in 1877 and Aaron Slater in 1878. Solomon Weinberg and Maurice S. Eberson, who both came to Lynn in 1880, Morris Mossessohn (1883), Jacob Rachesky (1885) and Reuben Basker (1884) were among the founders who participated in the growth of the community. Despite their inexperience and the language barrier, Jewish businessmen prospered in this new American enclave. Their success may indicate that they found a relatively welcoming environment in Lynn. Bankers from old Yankee families were surprisingly accommodating to the foreign accents and broken English that accompanied their new clients. The local citizenry, in the form of neighbors and customers of the stores, was mostly friendly and helpful.

Between 1880 and 1920, Lynn became home to thousands of eastern European Jewish immigrants streaming out of Russia and Poland and seeking refuge in the United States. Many fled to escape waves of pogroms, some to better their economic conditions and others as a result of the abortive 1905 revolution in Russia. Beginning in the 1880s, Lynn's shoe factories required more than ten thousand workers. Many Jews, having learned a trade in "der heim" (the homeland), were perfectly suited for the semiskilled employment opportunities available. They arrived from the ports of Boston and New York and were guided to Lynn by relatives and friends who had heard of the city's prosperity.

Meanwhile, the institutions of the Jewish community were serving the new immigrants. The Benevolent Society went on to found a synagogue

and purchase a burial ground in Wakefield. The members' wives organized themselves and, in 1896, founded the Ladies' Hebrew Circle, a group devoted to assisting the needy, tending to the sick and lending support to worthy community undertakings. The Benevolent Society spawned several other charitable and social organizations over the years, such as the Hebrew Helping Hand Society (1906) and the Menorah Society (1912).

In a few decades, the energetic young men and women who first arrived in Lynn created a rich Jewish life for themselves and their descendants. Many of the institutions that they created are still functioning today. The Jewish Social Service Agency, which they had founded at the turn of the century, is now the Jewish Family Service of the North Shore, headquartered in Salem. The Lynn Hebrew School, the institution perhaps most responsible for the continuity of Jewish life through its education of thousands of Jewish children over the years, is the precursor of today's Cohen Hillel Academy, a vibrant Jewish day school in Marblehead. Founded in 1904 as the Lynn Jewish Associated Charities, the Jewish Federation of the North Shore, with offices in Salem, is the lifeline of a variety of Jewish agencies and institutions that serve twenty-two local communities, collecting and disbursing charitable contributions and building links essential to Jewish life in this country and abroad.

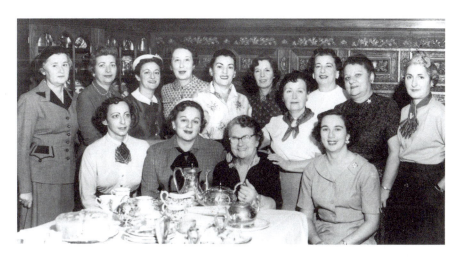

The Lynn Chapter of Hadassah luncheon meeting, 1955. For many years, the Lynn chapter has run a thrift shop at 14 Mount Vernon Street. Hadassah, the Women's Zionist Organization of America, was founded in 1912 and is committed to strengthening the unity of the Jewish people.

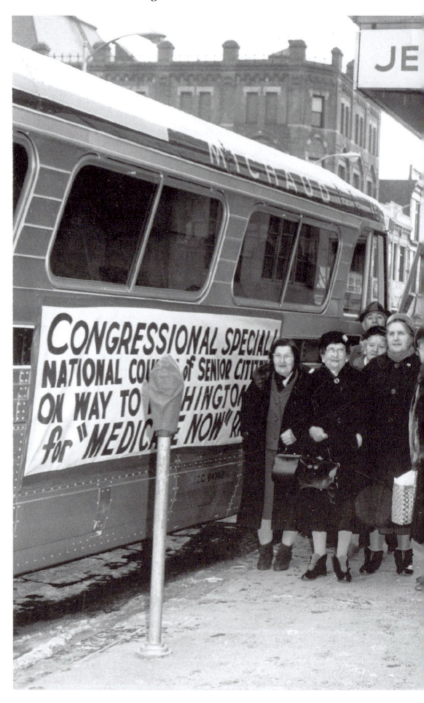

A group of active community women departing from the Market Street Jewish Community Center to travel to Washington, D.C., to lobby for Medicare benefits.

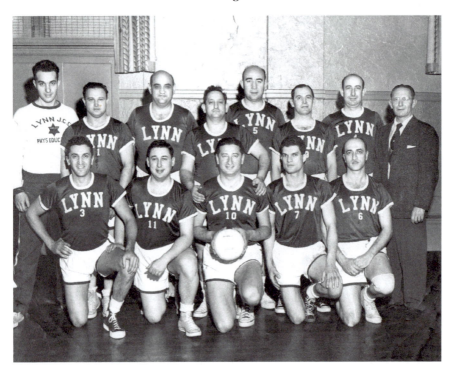

The Lynn JCC men's volleyball team. *Front*: Hy Ossoff, Frank Goldman, Sam Alpert, Sid Rose, Ralph Denenberg. *Back*: Bob Bache, Ed Shub, Harold Zimman, Harold Goodman, Irving Farber, Max Kremen, Lloyd Castleman and Sam Backman. The team represented the United States in the first Israeli Maccabiah in 1950.

The Lynn Young Men's Hebrew Association (YMHA) was launched by a small group of men at a meeting on October 17, 1911, for the purpose of "improving the spiritual, moral, mental, and physical condition of the Jewish young men of Lynn" through social, athletic, recreational and educational activities. Originally based at Congregation Ahabat Sholom, in 1913 the YMHA moved into rented quarters of its own: a clubroom and two small offices on the third floor at 122 Market Street. Led by first president Charles Goldman, age twenty-five, all of the founders were men in their twenties and younger. After the YMHA moved to 45 Market Street in the Central Square area of downtown Lynn, it became the Jewish Community Center, the hub of Jewish social, athletic and cultural life. Athletic teams flourished. Basketball, volleyball, bowling in the basement lanes and swimming at the indoor pool were popular pastimes. One of Lynn's most celebrated Jewish athletes is Herb Brenner, who turned ninety in 2009. Brenner, a successful basketball coach at Lynn Classical, is an inductee in the Hall of Fame at both Lynn English and Classical, where

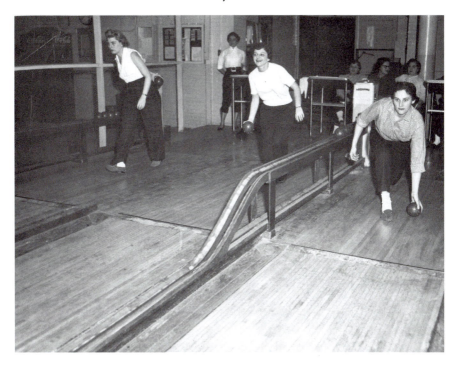

The Lynn Jewish Community Center at 45 Market Street had several candlepin bowling lanes, and these participants are members of the Women's Bowling Group.

the gym is named after him. Dances and dance classes, children's after school activities and card games drew young and old and every age in between. Now the Jewish Community Center of the North Shore, situated in Marblehead, the JCC is still a core institution of the Jewish community.

Remember the squeaky third-floor gym and the first-floor clubrooms at the JCC? And no one of a certain age can forget Minnie Pine and her daughter, Edie, who cooked Jewish delicacies at the center. Upon her death in 1979, the *Jewish Journal* reported:

> *There stood Minnie in the kitchen, the Queen of her domain, flanked by her daughter, with her hair glistening, her face moist from the heat. All was in order: steam rising from the kettles, the long trays of kugel with the crispy topping and the aromatic brisket ready to be cut, the gargantuan jars of relish waiting to be emptied. And there stood Minnie, the Sovereign, imperturbable and confident, directing and assigning trays to the waitresses.*

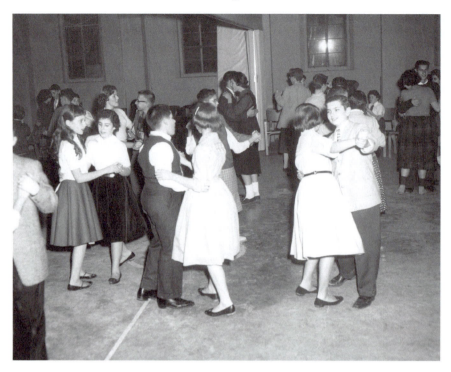

Teen and preteen dance classes and dances were popular events at the Jewish Community Center on Market Street.

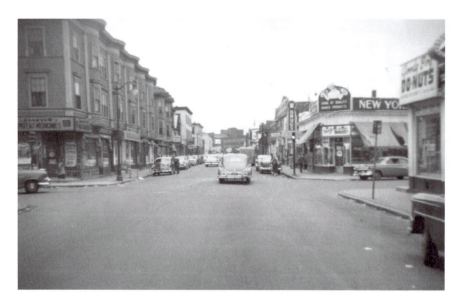

Summer Street, Lynn, looking toward Market Street, depicting several local businesses, including New York Model Bakery, circa 1958.

Lynn

Jews absorbed a rich culture that emerged from Socialism, Orthodox Judaism and the hybrid forms of Jewish life that each spawned in America. As did immigrants everywhere, the majority of Jews chose to live near one another. The neighborhood in Lynn came to be known affectionately as the "Jewish Ghetto." Bounded by Commercial Street on the west and Market Street on the east, Jewish Lynn, also known as "the Brickyard," evolved into a vigorous concentration of people united by a common past.

Thursday nights and Friday mornings were especially busy in the shopping district at Summer and Blossom Streets as Yiddeshe mamas purchased halvah, black bread, herring and challah at Jake Appel's grocery store. Some paused at Bluestein's, instructing him to slaughter fresh chickens for the Sabbath, or at Slobodkin or Weinshel's kosher butcheries, where they would purchase kosher meats and take part in the inevitable gossip.

From sundown Friday until sundown Saturday, the Jewish shops closed in observance of the Sabbath. By Saturday night, the area was packed with shoppers, half of whom socialized on the sidewalks, the other half procuring their supplies for the week. Reynold's Yard Good Store and Shultz Brothers Barber Shop attracted patrons and kibitzers alike. The Co-operative Bakery, established by a group of idealists to ensure bread for the workers at a reasonable price, became a lively gathering place in the new American Jewish experience. This neighborhood was to Lynn what Blue Hill Avenue was to the Jews of Mattapan or Shirley Avenue in neighboring Revere.

Among other Jewish businesses in Lynn, in the early to mid-twentieth century, were Ben's Tires, Lipsky's Moving Company, Max Frisch's Manchester Waste Co., Lisook Dry Goods, NY Delicatessen, Sheldon Pharmacy, New York Model Bakery, Hyman Weisman Meats, Merk Drug, Meritt Drug, Kay's Deli, Tobin's Egg Store, Sam's Fruit Store, Diamond Shoe, Brotherhood Credit Union, Morris Nadler Shoes, Stone's Bakery, Bessie Rubin Shoes, Philip Spack Men's Store, Atlas Delicatessen, Max Wheeler Bottlers, Harry's Lunch, Lynn Lumber, Melvin Shapiro Meats, George Leshner's Delicatessen, Slobodkin's Butcher Store, Samuel Kline Meats, Singer's Poultry Market, Maurice Goldberg Variety, Sam's Tailor Shop and Harold's Delicatessen on Exchange Street, next to Hotel Edison. Mel and Murray's on Lewis Street was also a popular delicatessen in Lynn.

Beginning in 1928, Louis Winer started the Alpha Delta Chapter of Alpha Phi Pi, a national Jewish high school fraternity with students from both Lynn Classical and Lynn English High Schools. Throughout the 1930s (with a short-lived revival in the '60s), Alpha Phi Pi, led by William

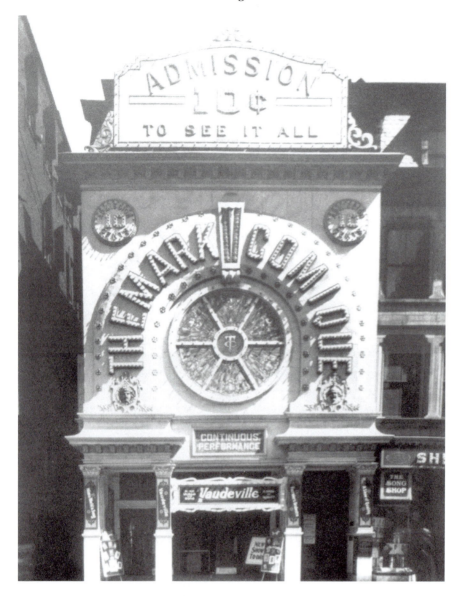

The Mark Comique Vaudeville Theatre was located on Monroe Street, Lynn. It was owned by Moe Mark, who also owned the Waldorf and Mark-Strand Theatres. All three theatres were sold to Warner Brothers in 1929.

Lynn

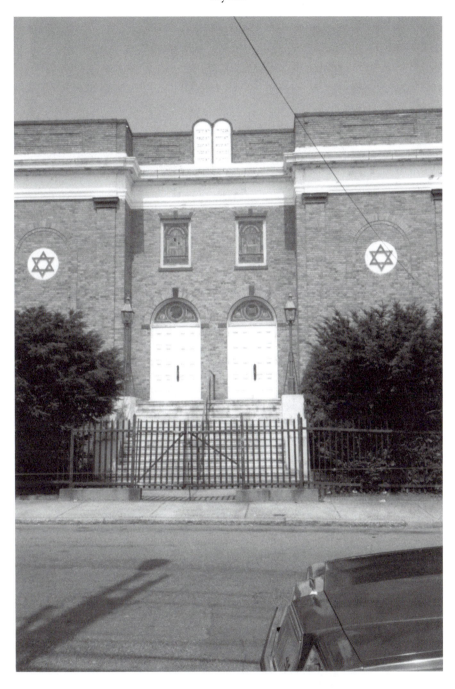

The front entrance of the original Temple Beth El on Breed Street in Lynn, which was subsequently relocated to nearby Swampscott. In 2005, Temple Beth El and Temple Israel, also in Swampscott, merged to form Congregation Shirat Hayam.

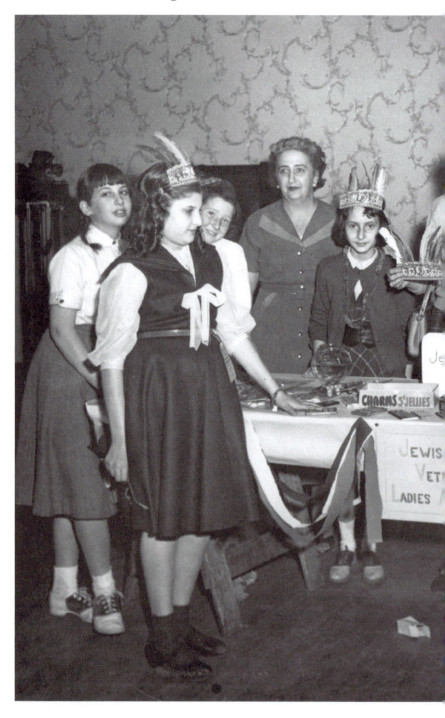

The Ladies Auxiliary of the Jewish War Veterans Post No. 31 providing refreshments at a Purim celebration in 1955.

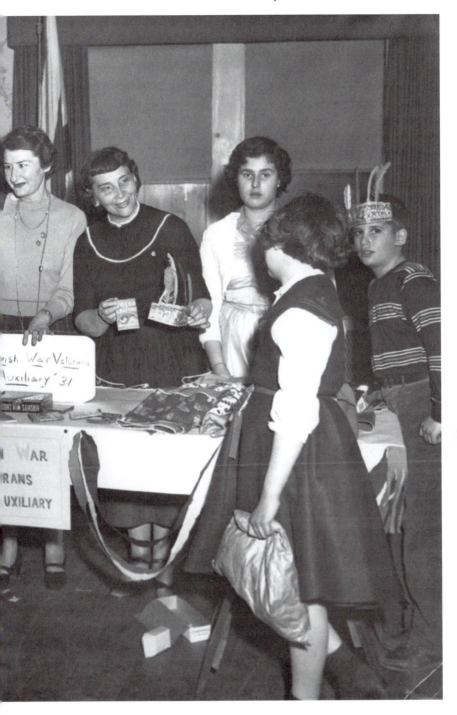

Pruss, held dances and other functions at Camp Nihan in Saugus and Suntaug in Lynnfield. The Intefor (Intercollegiate Forum)—whose first leader was David L. Winer, a Harvard Law student who went on to a long and successful legal career in Lynn—sponsored dances and debates for college-age men who also performed in plays such as *Arsenic and Old Lace* and *The Man Who Came to Dinner*. Intefor revenues and dues—originally five cents—helped to start Camp Simchah, the JCC summer day camp. In 1998, Intefor distributed $5,000 in scholarships to students beginning college. Other clubs for young people of that era were the Jecomen (Jewish College Men), the Mohawks for teens and the B'nai B'rith–sponsored clubs—BBG for girls and AZA for boys.

By the 1920s, when the oldest of the second-generation Jews had become established entrepreneurs and professionals, there was a growing urge among them for a new congregation that would be different from the Orthodox practice in which they had been raised. In 1924, many of the same men who founded the YMHA met to form Congregation Beth El. The congregation's members first met at the YMHA but immediately undertook the design and construction of the community's first non-Orthodox "temple." The congregation hired Israel Harburg, a Reform rabbi by training, but affiliated itself with the more traditionalist Conservative movement. Temple Beth El, the new synagogue on Breed Street in the heart of fashionable East Lynn, was dedicated in time for the High Holidays in 1927.

JEWISH SYNAGOGUES

By 1925, Lynn's Jewish population numbered approximately eight thousand. At that time, there were six Orthodox synagogues—Agudath Israel, Agudath Achim, B'nai Jacob, Anshe S'fard, Chevra Tehillim and Ahabat Sholom. Temple Beth El, located on Breed Street, was the first "Liberal" congregation, founded in 1927.

Congregation Anshe S'fard, located on South Common Street, was dissolved in 1999. Among its earliest spiritual leaders were Rabbis Bick, Carmi and Thaler. Its last and longest-serving rabbi was Samuel J. Fox. Congregation Chevra Tehillim, originally located on Shepard Street, moved to the Breed Street synagogue when Temple Beth El moved to Swampscott in 1968.

Rabbi Samuel and Rebbetzin Nell Zaitchik were honored in 1997 for fifty years of dedication and leadership of Congregation Ahabat Sholom and also of the Jewish community as a whole. Rabbi Zaitchik had served as chaplain and advisor on Jewish affairs to General Douglas MacArthur in Tokyo, Japan, following World War II. Rabbi Zaitchik was noted for masterful sermons and had been an active leader in many religious organizations, including the Rabbinical Council of America, the Massachusetts Board of Rabbis and the Synagogue Council of Massachusetts, among others. Nell Zaitchik was active in the Sisterhood and myriad other Jewish women's groups. Despite her busy life as rebbetzin, homemaker, mother and grandmother, she also was a licensed social worker.

Congregation Ahabat Sholom was founded in 1901 by Simon Weinberg, its first president. The members met in people's homes while they raised funds for a building. By 1905, services were held in a new edifice at 45 Church Street. For the first few decades, the congregation did not have a permanent rabbi. As membership increased after World War II, a full-time rabbi was needed. President Samuel Kurland invited Rabbi Samuel Zaitchik, a chaplain in the U.S. Armed Forces in World War II, to be guest rabbi for Passover in 1947. Rabbi and Mrs. Zaitchik remained with the

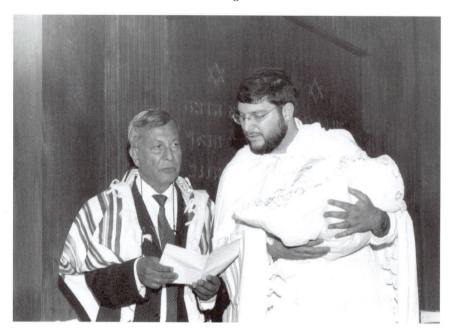

Rabbi Avraham Kelman at the *bris* and naming of his son, Baruch Lev. On the left is Rebbitzen Leora Kelman's father, Aharon Cohen of Israel, who was *sandek*.

congregation for the next fifty years. In 1962, the congregation dedicated a new building in Lynn's Diamond District on Ocean Street. The Orthodox synagogue, home to many of the Russian Jews who started to arrive in Lynn in the 1970s, houses the North Shore's only mikvah, *Mikvat B'not Yisrael*. The original officers of the mikvah were Bella Twersky, Minnie Singer, Shirley Mack and Debbie Herman Hallett. Rabbi Avraham Kelman is the current spiritual leader of Congregation Ahabat Sholom, which remains the only synagogue in Lynn today.

RUSSIAN RESETTLEMENT

The exodus of Jews from the Soviet Union created one of the most challenging and ultimately satisfying episodes in the history of North Shore communities, with special relevance for Lynn. Beginning as a Soviet Jewry Task Force of the Jewish Federation of the North Shore in 1968, yearly rallies in the early 1970s awakened the community to the plight of Soviet Jews

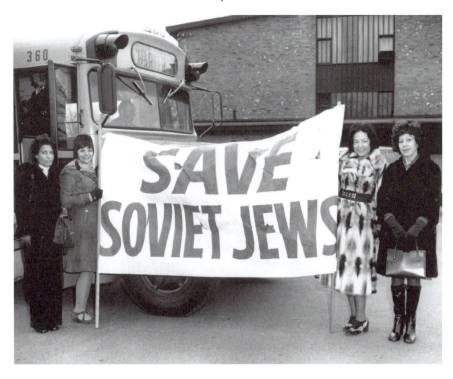

The Soviet Jewish Community was very active in participating in rallies and marches to save Soviet Jews and allow their immigration to the United States.

and cemented the resolve of the community to help. Dr. George Freedman, president of the Jewish Federation, and David Colten, director of Jewish Family Service, made the commitment to resettle Russian Jews in our area. Beginning with a few families in 1975, a trickle became successive waves, as Swampscott, Marblehead, Lynn, Salem and other communities mobilized their resources to welcome more than six thousand Russian-speaking émigrés in the succeeding twenty years.

Under the dynamic direction of Bernice Kazis, the Russian Resettlement program at Jewish Family Service of the North Shore spearheaded myriad efforts to help the newcomers. These included finding housing (mostly in Lynn, where apartments were more plentiful and less expensive), furnishing apartments with everything that families needed immediately and providing job placement services, English language lessons and even a handbook of practical information about life in their new community. Synagogues, the Jewish Community Center in Marblehead, Cohen Hillel Academy and

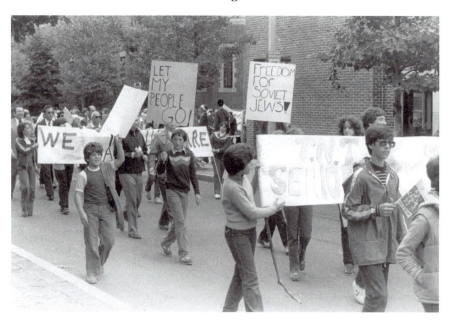

A rally for Soviet Jews on the North Shore, culminating in a march through downtown Salem in 1980.

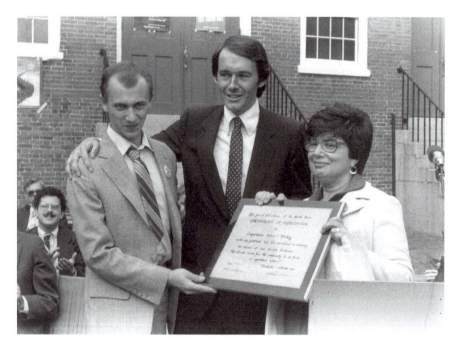

At a rally in Salem in October 1980, Mark Khayter and Inga Malenbaum presented U.S. Congressman Edward Markey a Certificate of Appreciation for securing the release of Soviet Jews.

the *Jewish Journal Boston North* were among the institutions that contributed resources to the newcomers, including memberships and tuitions.

Community members, organized by committees in each of the North Shore synagogues, donated household items, furniture, clothing and, perhaps most importantly, hospitality in their homes. In *Short Stories of a Long Journey*, an oral history of Russian Jewish resettlement in our area (written by Bernice Kazis, with Elaine Bakal and Zelda Kaplan, and published in 2002), Russian interviewees remembered learning about observance of Shabbat and Jewish holidays in the homes of local people, some of whom became like family. Today, as the former Soviet Jews have taken their places as successful members of the North Shore community, both the helpers and those whom they helped can look back with pride and appreciation on what they learned and what they experienced in an enriching process for everyone involved.

MOVING OUT OF LYNN

Like other upwardly mobile ethnic groups, the Jews worked hard at their crafts and professions, enabling their children to have an easier life. After World War II, college-educated, American-born Jews abandoned the triple-deckers and the urban Jewish ghetto for the comforts of suburbia. Many settled in Marblehead, Swampscott, Peabody, Lynnfield and other North Shore locales, where they continued to build and support the institutions of the Jewish community. The latter part of the twentieth century has seen further population shifts to the more rural areas of Topsfield, Boxford and Middleton.

And Lynn? The urban flavors of its Jewish neighborhood—its streets, synagogues and institutions—are now gone; urban renewal has bulldozed most of them away. Other immigrant groups have come to claim Lynn as their haven. Fewer than one thousand Jews, mostly the elderly, now live in the city. What remains is Lynn's central place in the history of the Jewish community of the North Shore, as well as the personal histories of generations of Jewish families. Lynn's Jewish community is present in the memories of parents, grandparents and great-grandparents whose descendants are sensitive enough to preserve them.

The late Nathan Gass was a founder of the Jewish Historical Society of the North Shore; additional material was provided by Alan S. Pierce and Barbara Tolpin Vinick.

Immigrant Entrepreneurs: Jews in the Shoe Trades in Lynn, 1885–1945

Stephen G. Mostov, PhD

Thousands of Russian Jews came to Lynn to work in its shoe factories. The economic life of the Lynn Jewish community was inextricably linked tó the shoe industry, which became the major source of the Jews' upward economic mobility. Even as the electrical industry developed in their midst, and the city's other immigrants became increasingly involved in it, immigrant Jews remained wedded to the shoe industry and its allied trades. The history of the Jews' participation in the Lynn shoe trades is a paradigm of the economic history of the two million Russian Jewish immigrants who settled in America between 1800 and 1924 and who laid the foundations of the Jews' present-day high economic status.

With the mechanization of shoemaking and the change to factory production, the physical transformation of Lynn from a quiet town into an industrial city began. Previously, the small shoe workshops had been located in all parts of town. But when factories were built, they needed to be located near the center of town, within easy access to the central railroad station. The area around the depot—known as Central Square—became a congested commercial and industrial area, as some forty factory buildings were built on the surrounding blocks between 1850 and 1880. As a result, the population of Lynn more than doubled, from fourteen thousand in 1850 to thirty-eight thousand by 1880.

Slowly, the Jewish community in Lynn grew in size. By February 1886, a *minyan*—the ten-person minimum required by Jewish tradition to hold religious services—could be consistently gathered, and a congregation was formally incorporated. The Hebrew Benevolent Society, as the organization was named, became the city's first Jewish institution. It was a combination congregation, mutual aid and burial society. In the years to follow, the previously intermittent flow of new Jewish arrivals became a steady stream and continued to grow in size over the next three decades. The arrival of these immigrants was but the local manifestation of the mass exodus of

Jews from Russia to the United States, an exodus that so altered American Jewish society.

The Russian Jews arrived in America as "greenhorns"—foreigners, barely able to communicate in English and ignorant of American ways. In their initial desperate need for shelter, food and employment, they instinctively depended on their friends or family members who had arrived earlier or on fellow *landsleit* (townsmen). Those who found their way to Lynn invariably headed straight for the Jewish neighborhood, where they were quickly absorbed into the rapidly evolving, close-knit Jewish immigrant community.

The Jews settling in Lynn were of more diverse origins than the Jewish population of a typical Russian village would have been. Because emigrants were arriving from all parts of the Russian Pale, as well as from other areas of eastern Europe, the Lynn Jewish community was neither as homogenous nor as internally united as it appeared to be. The two major subgroups among the immigrants were those from Lithuania in the northern part of the Pale and those from the Ukraine and southern provinces of the Pale. In addition, a third group included the community's founders, who had already formed a separate social elite.

These differences found expression in the early history of the community's congregations. Congregation Ahabat Sholom was formed in 1898 and chartered in November 1901. In April 1905, its members moved into the first synagogue built in Lynn. The dedication of the $17,000 structure was cause for a major community celebration, attended by the city's mayor and other officials. Ahabat Sholom originated as an outgrowth of the old Hebrew Benevolent Society, and in fact, its first president was the community's "patriarch," Simon J. Weinberg. As the immigrant population grew, however, the founding group was overwhelmed by the number of newcomers. Dismayed by the congregation's increasingly immigrant character, the founders formally withdrew their memberships in 1911 after their efforts to institute aesthetic and religious reforms was rebuffed by the new majority. From that time on, the congregation was commonly referred to as the "Litvische shul"—that is, the congregation of the Lithuanians, the community's majority group. Congregation Anshai Sfard, formed in 1898 and chartered in June 1899, was the major congregation of the smaller group of Jews from southern portions of the Russian Pale (from Kiev to Odessa). Although also strictly Orthodox, its services followed a slightly different *minhag* (prayer custom). It came to be known as the "Russiche Shul" (Russian Synagogue).

Having arrived in America, personal connections such as family or friends usually determined where an immigrant first settled. But it was not just chance that sent thousands of Jews heading to Lynn, a city of shoe factories. Among those who had worked before immigrating, a majority had previous training and experience in the "needle trades," of which shoemaking was one. Therefore, for many of them Lynn was an especially good place to begin the search for work.

A typical case was Harry Weinstein, who emigrated from England in 1914 and ended up settling in Lynn specifically because of its many shoe factories. Weinstein had worked for seven years as a skilled cutter in a London shoe factory. Within a few days of the time he landed in New York, he was in Lynn "in search of work," and within another two days he had found employment. What was unusual about Weinstein was that he was from industrialized England, and therefore his previous shoemaking experience had been in a factory. Most of the Jewish shoemakers coming from Russia came from towns and villages where shoes were still handmade, with the only shoe machinery being an occasional sewing machine. They were artisan shoemakers of the type common in Lynn in the pre-factory era.

The Jewish shoemakers entering the Lynn factories had a solid technical knowledge of how to make a shoe and also knew how to go about selling them. Once in Lynn, Jewish immigrants of all occupational backgrounds sought to adapt to the shoe trades. Those who didn't go to work in the factories often came to be connected with the local shoe industry through forms of petty trading and brokering reminiscent of Jewish commercial activities in the Pale. In Russia, the major local industry was agriculture, and therefore the petty trade of Jews had centered upon agricultural products and by-products. Since the major industry in Lynn was shoe manufacturing, unskilled but enterprising Jewish immigrants soon became involved in petty trades connected with it. They discovered, for instance, that shoe factories produced large quantities of scrap leather, defective shoes and other seemingly worthless by-products. Some of the Jewish men began collecting these junk items, cutting them up into salvageable pieces of leather and then reselling them. It was in this rather inglorious manner that Jewish involvement in the shoe industry's allied trades began.

By every measure, Lynn was the nation's leading shoe city. In 1911, there were 103 shoe manufacturing firms in Lynn, employing more than twelve thousand workers. The Lynn factories were producing 15 million pairs of shoes per year, with a market value of $33 million. In addition,

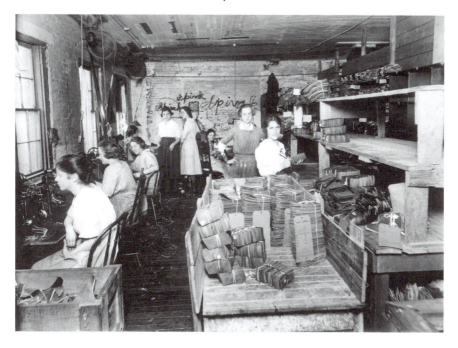

Many women were employed in the shoe factories of Lynn in the early part of the twentieth century.

there were more than 100 local firms in allied leather and service trades. Geographically, Lynn was located near the heart of the world's greatest shoe and leather market. The shoe factories of eastern Massachusetts, including the major centers of Haverhill and Brockton, as well as Lynn, had annual output of more than 100 million pairs of shoes—which was more than 40 percent of the nation's total output.

The vast shoemaking capacity of Lynn had come to be concentrated in a densely built-up factory area of less than twenty square blocks, radiating off Central Square. It was an area that had to be rebuilt following a major conflagration in November 1889, which had totally destroyed 338 buildings in the heart of the city. By 1910, this small and compact downtown area was a mass of large brick shoe factories—more than 75 in all. The buildings were four to eight stories tall, with walls consisting of large, closely spaced windows. They were solid structures, thought to be thoroughly fireproof. The centerpiece was the Vamp Building, so named because its shape resembled that of a triangular shoe vamp pattern. Local boosters proudly touted that it was the largest shoe factory building in the world.

Jewish workers had no exceptional problems with their "Yankee" bosses—in the large factories, they were remote figures, and the workers rarely talked to them or saw them. The people directly overseeing their work were foremen or supervisors. Initially, there had been problems of a religious nature for Jews, as Saturday work was insisted on and Jewish workers were not allowed the Jewish holidays off. Jewish workers also got along well enough with their non-Jewish co-workers, but there was little close social fraternization outside the factory. Some of the Jewish workers started to join fraternal orders such as the Odd Fellows, the Eagles and the Knights of Pythias. But as their numbers within these organizations increased, special Jewish lodges were created, reinforcing the Jewish workers' social distance from non-Jewish workers.

By 1913, there were at least five Jewish fraternal organizations, with several lodges each. The two largest were the International Order B'rith Abraham, which had three lodges and 665 members, and the Jewish Workingmen's Circle (the Arbeiter Ring), which had four lodges and 700 members. The Arbeiter Ring was dedicated to promoting Jewish Socialism and as such had the most explicitly working-class orientation of any of the Jewish fraternal groups. In addition to the fraternal societies, there were a variety of other Jewish organizations oriented toward the needs of working-class Jews. Among them were a credit union and several small socialist political groups.

The desire to have a business of one's own—no matter how insubstantial—was an irrepressible part of the immigrant Jews' psyche. For so many generations their fathers, grandfathers and earlier descendants had worked as peddlers, petty merchants or independent artisans that these forms of self-employment had become second nature to eastern European Jews. It was this underlying inclination toward economic opportunism and independence that more than any other single factor explains why so many of the Jewish immigrants eventually would attempt to establish businesses of their own.

Harry Weinstein typifies the difficulties of the initial economic adjustment—although as a skilled cutter he was better off than many others. His first job was as a cutter for the small Jewish-owned nonunion shoe findings firm of Lyons and Hershenson. Other than the owners, the entire workforce consisted of a foreman, an office clerk, two cutters and other workers whom Weinstein describes as "seven or eight greenhorns, who had only been in the country a few months." Everyone worked eleven-hour days and five hours on Saturday. Harry's initial wage worked out to about $15 per week, half

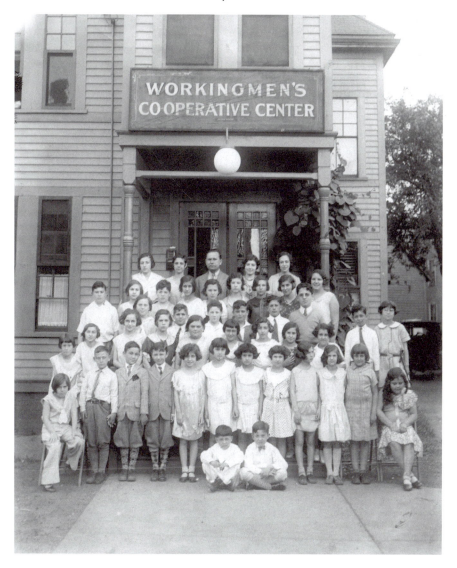

Workingmen's Cooperative Center (circa 1926).

of which he would immediately wire back to his wife in England. The only money he spent on himself was a few dollars a week for room and board. He rented a room and ate his dinner at the home of a friend, whose wife "cooked Kosher meals for some of the Jewish shoeworkers...a four-course meat meal for 25 cents, with chicken for 35 cents on Friday." Within half a year, Weinstein had somehow managed to save up the $180 he needed to

pay for the passage of his wife and children, and had purchased his first $25 worth of furniture.

The first substantial shoe manufacturing firm in Lynn with a Jewish owner was the firm of Tufts and Friedman, established in 1901. It was one of the few Lynn firms ever to make men's and boy's shoes. Albert Friedman was a resident of Boston, the son of a prominent Boston shoe manufacturer. The firm remained in business in Lynn until 1924, but Friedman never lived in Lynn, nor was he a part of the local Jewish community.

The era of immigrant-owned shoe firms began a decade later with the founding of the firm A. Jacobs and Sons in December 1910. Abraham Jacobs had emigrated from London in 1880, where his family had been in the shoe business. He moved to Lynn from New York in 1909 and went into the leather remnants business with a salesman named Jacobson. A year later they began manufacturing infants' shoes. It became a common practice for aspiring Jewish shoe manufacturers to begin by making infants' or children's shoes, since they could be made from the leather remnants with which so many of them dealt.

Between 1915 and 1930, close to one hundred different shoe manufacturing firms were started up by the city's immigrant Jews. The majority of the firms were short-lived, however, as individuals went in and out of business and changed partnerships at a dizzying pace. Nearly one-third of the firms were out of business within one year, two-thirds within three years and three-fourths within five years. The number of firms in business at one time rose from nine in 1918 to nineteen in 1925 and to thirty-one in 1927. While each of these firms had its own unique origins, there were common patterns in how they came to be established.

Most partnerships involved familial as well as business ties, as brothers, sons and in-laws were brought into the firm. In the case of one prominent Jewish-owned firm, the partnership consisted of husband and wife as full and equal owners. The Liberty Shoe Company was started in 1921 by David and Sarah (Sadie) Ashkenazy. The Ashkenazys were born and married in Russia and immigrated to Lynn in 1910. They began in the shoe business by starting a leather remnants dinking shop in the basement of their home. In 1921, they began manufacturing shoes in a small workshop, with a production rate of 150 pairs a day. By 1927, they were operating a factory producing 1,000 pairs a day, with assets of $15,000. Mrs. Ashkenazy was in full charge of day-to-day operations inside the factory and became well known locally as the city's prominent female boss.

Lynn

Many of the Jews starting up manufacturing shops had worked in the large factories and had thus been union members. But once they started firms of their own, many of them refused to allow the unions to organize their workers. For these owners the issue was not one of wages, but rather a fear of relinquishing control over their shops. Many of the Jewish owners adopted an almost paternalistic attitude toward their workers and took pride in the fact that their workers seemed to think kindly of them. Summer picnics and Christmas parties were one common way of promoting good relations. It was an anomalous situation for immigrant Jews to suddenly be the "boss" of large numbers of non-Jewish workers, and this was bound to become a source of resentment in times of labor strife. But it had relatively little effect on the Jews' status within the city as a whole. Jewish entrepreneurs remained an insular immigrant group, even as they became progressively middle class.

As an increasing number of immigrant Jews succeeded in becoming established entrepreneurs, the Jewish community of Lynn began to change in character. What had been a working-class community of newly arrived immigrants gradually became more prosperous and Americanized. The changes were reflected in the evolving middle-class lifestyle of the successful entrepreneurs. But even so, the immigrant Jews continued to comprise a cohesive community, centered upon family, friends and synagogue.

The most successful of the manufacturers moved into houses in the so-called Diamond District along the ocean, from which immigrants had traditionally been excluded. Many, however, chose to remain in the Jewish neighborhood or settled in nearby areas such as Lynn Highlands or the blocks just north of the Common. Mostly, their lifestyle remained relatively unchanged. Whether or not the immigrant Jews remained strictly observant, most remained active members of one of the two Orthodox synagogues in the Jewish neighborhood—Ahabat Sholom or Anshai Sfard.

Jews who lived in the Diamond District, for instance, would be more apt to socialize with their friends living in the Jewish neighborhood than with their new neighbors. A daughter of one of the successful manufacturers recalls how even after her family had moved to the Diamond District, the family still spent their Saturday evenings down on Blossom and Summer Streets. She and her mother would make the rounds of the Jewish butchers, grocers, fish stores and fruit and vegetable stands, haggling and bargaining with the shopkeepers and socializing with their friends in the process.

Temple Beth El confirmation class, 1947. In the back row, center, are teacher Rose Price and Rabbi Israel Harburg.

The children of adult Jewish immigrants—whether born in America or brought over from Europe at a young age—had an upbringing radically different from that of their parents. This second generation in America consisted of children raised in an open society, far different from the *shtetl* life so many of their parents had experienced. For their children, English came to be a native language. They went to public schools, where American culture and traditions became their own.

To be a Jewish child in Lynn during the 1910s and 1920s, with few exceptions, meant living, playing and going to school in the downtown district. Most families were large, and since the neighborhood was crowded and compact, the Jewish children quite literally grew up with one another. They attended the Washington, Shepard or Cobbet grade schools and later went on to one of the two large city high schools—Lynn Classical or Lynn English. It was a sheltered life, in which children rarely ventured beyond the immediate neighborhood and had a narrow view of life in America—both Jewish and generally.

In 1922, the Jewish community established the Lynn Hebrew School in a separate, refurbished three-story building. The new school was described in the contemporary local newspapers as "large, airy, and sanitary" and was said to be "built on the latest plan of public schools." The Lynn Hebrew School was dedicated on July 2, 1922, in an elaborate ceremony attended by three thousand people. The ceremony included speeches by high city officials and was preceded by a large parade from the old school to the new.

In the schools, relations between Jewish and non-Jewish kids were considerably more civil, but a certain social distance was maintained. The Jewish youth had their own social clubs and their own outside activities. Interdating between Jews and non-Jews was rare, and intermarriage almost unheard of. As one woman who grew up in the neighborhood put it, "If there was an intermarriage in the city it was terrible—it was like a death, and was treated like a death."

Whether the second-generation Jews went to college or not, they invariably ended up back in Lynn to begin their working careers. This was in large part due to close family and personal ties, but also was dictated by economic necessity. The small minority who received professional training—usually as accountants, lawyers or doctors—found it difficult to start a practice anywhere other than Lynn. Young women—even the few with college degrees—found themselves dependent on family and friends for employment. One woman who graduated from college has bitter memories of the discrimination that

she faced in trying to find managerial work. In the end she, like others, had to settle for "unequal pay for equal work." Once they got married, the second-generation Jewish women generally ceased to work outside of the home.

The decline of the local shoe industry was mirrored in the decline of the Jewish community in Lynn. In the decades following the end of World War II, the second-generation Jews abandoned Lynn for the nearby towns of Swampscott and Marblehead. Already by 1955, half of the ten thousand Jews of Greater Lynn lived in the neighboring towns. There, a transplanted community of young and increasingly affluent Jews quickly took form, and a new generation of Jewish institutions arose. Swampscott and Marblehead were suburban communities of spacious houses and quiet streets—a different world from the bustling downtown Jewish neighborhood of old. By the 1960s, only a small number of mostly elderly Jews still lived in Lynn's rapidly aging downtown district. A few years later, the neighborhood itself ceased to exist in its old form, as houses, streets, schools and even the old Ahabat Sholom synagogue were razed to make way for urban renewal.

In 1981, all that remained of the Lynn shoe industry were a few scattered firms and several hundred jobs. All that remained of the Jewish community in Lynn were the one thousand or so Jews living in the Diamond District area. The massive factories constructed after the fire of 1889 stood empty and forlorn—lining the downtown streets like tombstones. On November 28, 1981, the factories again began to go up in flames. A fire spread from one empty building to the next in a conflagration of historic proportions. For one final, fleeting moment, the nation became conscious of Lynn's historic past, as banner headlines and news bulletins described the devastation of the shoe factories. Appropriately, the wire service photo appearing on newspaper front pages from coast to coast captured in bold relief the charred storefront of Musinsky's, the pioneer Jewish shoe store in Lynn. The smoldering ruins of the Lynn factories marked the literal end of an age. They were a sad epitaph to a centuries-old local industry, predating the nation, which in its old age had served the Jews so well.

This text by Stephen G. Mostov, PhD, is from a monograph (abridged) written for the Jewish Historical Society of the North Shore in 1982.

SWAMPSCOTT
AND MARBLEHEAD

S wampscott is a beautiful seaside community fifteen miles northeast of Boston. Its Native American name was *M'squompskut*, meaning "at Red Rock." Marblehead, a picturesque seacoast town and sailing capital adjacent to Swampscott, is steeped in American history. Originally inhabited by the Naumkeag Tribe, the town was called *Massebequash*. This chapter focuses on the towns' spiritual, cultural, charitable, commercial and professional contributions to Jewish life.

SWAMPSCOTT'S EARLY JEWISH COMMUNITY

Edye Comins Baker, Helaine Roos Hazlett and Barbara Tolpin Vinick

There are many fishermen but no Jewish residents listed in the Swampscott street directory of 1856, the first since Swampscott's separation from Lynn. The first Jews in Swampscott were part-time residents—wealthy families from Boston who came to Swampscott for the summer's cooler air around the turn of the nineteenth century. Among the families listed in the 1899

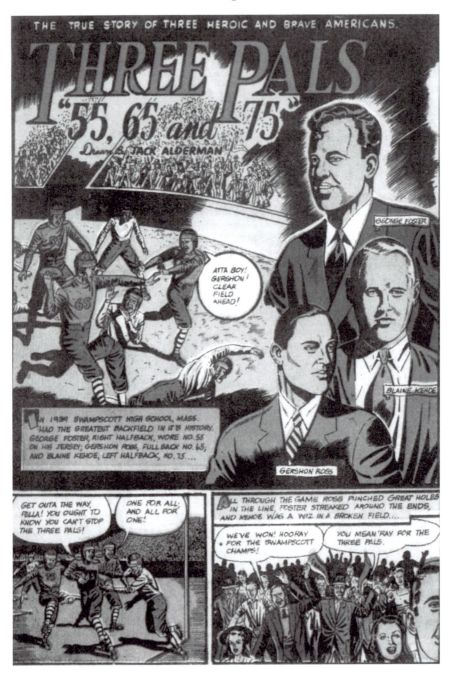

A 1945 comic book depicted Gershon Ross, a fullback for the Swampscott High School football team in 1939. Ross was a celebrated athlete at the high school. He died in service to his country.

street directory are Eiseman, Friedman, Morse, Vorenberg and Ratshesky, several on Humphrey Street. (Most were among the founders of Kernwood Country Club in Salem in 1914.) Notably, in 1903, Israel Ratshesky, who with his brother Abraham founded the U.S. Trust Company, the first "Jewish" bank in Boston, purchased Beachhurst, a Stick-style house on Puritan Road designed by the most prestigious architect of the day, Richard Morris Hunt. One hundred and four years later, in 2007, the house would become the Designer Showhouse of the Jewish Community Center of the North Shore.

By the time of World War I, Swampscott Jewish residents included working-class families. The street directory of 1916 lists Samuel (occupation "rubber goods") and Sadie Bornstein on Suffolk Avenue, Harry (occupation "junk") and Anna Sherman on Elm Place and shoe worker Oscar Waldman and his wife Julia on Hillside. In addition, there were three Jewish tailors. Mark Damsky, "Ladies' and Gents' Tailor and Furrier," who lived in Lynn, advertised his shop on Redington Street. Tailor Samuel Levitsky's shop was located at 416 Humphrey Street, where he lived with his wife Ida. Benjamin Weinstein operated what must have been a rival shop down the street at 224 Humphrey, where he lived with wife Esther.

The Jewish presence in Swampscott continued to grow as Jews moved over the border from Lynn to Swampscott. By 1929 there were, for example, seven different Cohen families and four residences housing Freedmans. Manuel Ross, a leather merchant, lived on Banks Road. His son, Gershon, was memorialized in a Catholic cartoon magazine article in 1945 (*Timely Topix*, published in Minneapolis, drawn by well-known cartoonist Jack Alderman) as one of three football heroes, Swampscott High School pals, who died in World War II—Gershon Ross, a Jew; Blaine Kehoe, a Catholic; and Protestant George Foster.

MARBLEHEAD'S EARLY JEWISH COMMUNITY

On June 1, 1775, Abraham Solomon enlisted in Colonel Glover's Twenty-first Regiment (known as the Marbleheaders) to fight the British in the

Revolutionary War. When soldiers received their pay, they signed the muster roll, the list of men in the regiment. Abraham Solomon signed his name in Hebrew. This is the first evidence of a Jewish presence in Marblehead.

The turn of the twentieth century offers the next evidence of Jews in Marblehead, many of them early entrepreneurs. Abe Sklover, who lived at 38 Mugford Street with his wife, Dora, opened a tailor shop at 80 Washington Street in 1898. Barney Verner, who emigrated from Kiev, Russia, in 1904, rented a cold water flat on Hawkes Street and opened a furniture and antiques store at the corner of State and Washington Streets. In 1912, Verner sold the shop to Abraham Sacks. (Today, it remains in the Sacks family and operates in the same location.)

Louis and Ida Shube, originally shop owners in Lynn, moved to Marblehead in 1924 when they opened a popular market. Generations of Shubes have followed in their footsteps. Son Bill opened an adjacent liquor store in 1948, and starting in the late 1970s, grandson George expanded several times on Atlantic Avenue, where Shubie's (as the market was renamed in the 1980s) is now located in a newly designed market building selling a vast selection of prepared foods and wines.

About 1925, Isaac and Dora Kemelman, emigrants from Russia who spoke limited English, purchased a parcel of land and began construction on several shops that fronted on Humphrey Street in the Beach Bluff section of Marblehead. When Isaac became ill with tuberculosis, Dora became the overseer of the building project, journeying from Boston's Mattapan section by public transportation. In spite of her language and transportation limitations, the commercial project was completed. The Kemelmans' son, Harry, operated a hardware store on the block before becoming the famous author of mysteries set in a town much like Marblehead. Another store, originally Nationwide Supermarket owned by Isaac Kemelman himself, became Beach Bluff Supermarket, commonly referred to as "Leshner's" or "Goldstein's," depending on whose business you frequented in Lynn, before they joined forces and moved to Marblehead. Until recently, the space held Grossman's Delicatessen. Many will remember Beach Bluff Pharmacy in that block of stores operated by Moe and Dave, whose soda fountain and extensive cosmetic section were popular in the 1950s, '60s and '70s.

During the 1930s and '40s, the cooler climate brought many "summer people" to Marblehead, including Boston residents G. Irving and Esther Hillson and shoe manufacturer Lassor and Fanny Agoos, who rented cottages

or built homes in the Clifton area. (Their descendants recall vividly the chilly reception that greeted them.) Homeowners or renters were augmented by Jewish vacationers who stayed at the Preston Beach Hotel, purchased in 1934 by Sonny Sonnabend, later to found the Sonesta Hotel chain.

World War II signaled the beginning of an upsurge of Jews seeking homeownership, good schools, safe and quiet streets and clean air that suburbs like Swampscott and Marblehead could provide for young families. Upwardly mobile families from Chelsea, Everett, Malden and Lynn bought homes in Swampscott and Marblehead, often with the help of real estate broker Ethel Carlyn. Phyllis Sagan of Sagan Realty recalls that when she began selling real estate thirty years ago, Jewish clients were never shown property and Jewish brokers did not have listings on Marblehead Neck, Peaches Point or West Shore Drive. Those unspoken restrictions, like other barriers from the early days of Jewish migration, have been largely eliminated.

The postwar years saw the beginning of institutions that have served these Jewish communities through the twentieth century.

Religious Institutions

Temple Beth El

From its founding in 1924 by a group of young men who wanted to create a Conservative synagogue in Lynn, Temple Beth El became a core institution of the Jewish community. Religious services were held at Lynn's YMHA (Young Men's Hebrew Association, forerunner of the Jewish Community Center of today) until an impressive, domed synagogue was built on Breed Street in 1927. Rabbi Israel Harburg, known for his scholarship and learned rhetoric, became the first spiritual leader of the congregation, serving twenty-eight years from 1928 to 1956. Beginning under the leadership of the first president, Henry Yozell, the congregation increased rapidly following World

Adult Bat Mitzvah celebration. Temple Beth El, Swampscott, June 5, 1999. *Front:* Marcia Simons, Barbara Toby, Ethel Schultz, Eunice Brody and Thelma Hoch. *Back:* Cheryl Brandwein, Betty Ross, Sandra Germain, Robin Cooper, Cindy Blonder and Lory Friede Zaifman. *Courtesy* Jewish Journal Boston North.

War II, when returning GIs settled in Lynn and surrounding communities to raise their families, many of whom wanted to modify their practice of Judaism from the Orthodox ritual of their childhoods.

Steven Schwarzchild (1960–64), especially loved by young people in the three-days-a-week Hebrew School, led the congregation to a central place in local and national civic affairs. Many remember his journey to Selma, Alabama, to march with those opposing racial segregation. A legacy of his tenure was a temple social action committee, which in the early 1970s spearheaded a Vietnamese dinner to raise money for the Committee of Responsibility, an organization devoted to bringing Vietnamese children to the United States for medical treatment and rehabilitation. Several hundred people from Jewish and non-Jewish religious groups attended the dinner prepared by well-known caterer Edie Pine, raising several thousand dollars and garnering substantial media attention.

By the time Rabbi Ephraim Bennett joined the synagogue in 1964, the Jewish population was shifting from Lynn to surrounding suburban communities, and the membership had outgrown its Breed Street home. High Holiday services had been held at alternative sites, including the Surf Theatre on Humphrey Street in Swampscott. In 1968, Temple Beth El moved to a beautifully designed and landscaped new building at 55 Atlantic Avenue in Swampscott. There, active Brotherhood and Sisterhood organizations raised funds for temple projects with fashion shows, rummage sales, concerts, current events forums, father and son sports breakfasts and barbecues.

Throughout the decades from 1948 to 1980, Cantor Morton Shanok held a central place in synagogue life, taking a leading role in prayer services, teaching Bar Mitzvah boys (and later Bat Mitzvah girls) and directing choirs of schoolchildren, women of the congregation and the professionals who sang regularly at services. But much else changed during that time. The second wave of feminism ushered in a new era of egalitarian principles in Conservative Judaism. Beginning in the early 1970s, women ascended the *bimah* (platform from which the Torah is read) for aliyahs, celebrated Bat Mitzvahs and were elected to the Temple Beth El Board of Directors. In 1975, led by member Kate Borten, space was allocated for a preschool under the direction of Leslie Rooks Sack, who continues in that role today. It wasn't until 1986, however, that Diana Caplan became the first female president of the congregation.

Following the brief tenure of Rabbi Judah Kogen, Rabbi Edgar Weinsberg arrived at Temple Beth El in 1985. For the next twenty years, Rabbi Weinsberg, who also holds a doctorate in gerontology, dedicated himself to Temple Beth El, building interfaith alliances with other religious institutions on the North Shore.

As the Conservative movement lost momentum in the 1990s, the memberships of both of Swampscott's Conservative temples declined. An earlier effort to merge Temple Beth El with Temple Israel had not been successful, but urgency to regain the religious vitality of the past and to continue into the future as a strong Conservative presence led some intrepid Jewish leaders to try again. Under the leadership of Rabbi Weinsberg and President Helaine R. Hazlett, Temple Israel was approached to reconsider a plan to consolidate the congregations. As a first step, the preschools of both temples were merged in 2003. Larry Kahn became Temple Beth El's first chair of the B'reshiet ("In the beginning") committee, followed by

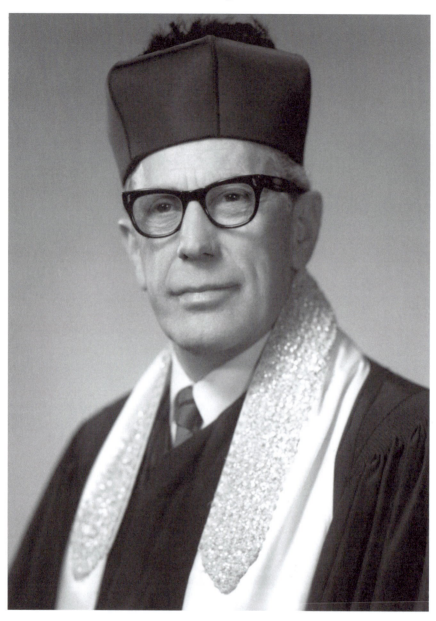

Cantor Morton Shanok (1911–2006). For over sixty years, Cantor Shanok worked as a cantor and chaplain and was one of a group of cantors who established the curriculum at the College of Jewish Music in New York, affiliated with the Jewish Theological Seminary. His first cantorial post was at Temple Beth El in Rockaway Park, Long Island, New York, where he served from 1938 to 1942. After World War II, he came to Lynn and served for thirty-two years as cantor of Temple Beth El of Lynn and, later, Swampscott. He then served for six years as the High Holiday cantor at Temple B'nai Abraham in Beverly. He also served as the religious cultural coordinator at the Jewish Rehabilitation Center in his later years. *Courtesy William Charles Studio.*

co-chairs Scott Smith and Richard Wise, along with representatives from Temple Israel. On May 19, 2005, after much convincing and compromising, Temple Beth El and Temple Israel dissolved, and the new Congregation Shirat Hayam was established.

TEMPLE ISRAEL

In 1946, a group of men led by Eli Cohen, Harry Weinstein, Cecil Weinstein and Adrian Comins resigned their affiliation with Temple Beth El and formed Temple Israel. This was in reaction to a serious rift that had developed within the Lynn Jewish community over the fundraising techniques of the UJA (United Jewish Appeal) combined with the postwar growth of the Jewish populations of Swampscott and Marblehead. Soon after, ground was broken at 837 Humphrey Street in Swampscott, and the basement was built. The flier that announced the groundbreaking on June 15, 1947, read, "Movies will be Taken—Bring the Children." (Those films have survived and are in the archives of the Jewish Historical Society of the North Shore.)

With Harry Weinstein as the first president of the new congregation, services were held in 1947 in the basement of the unfinished building (called "the vestry") when the cement was still damp. After several years of visiting rabbis, Rabbi Abraham Karp became the first full-time rabbi in 1949, followed by Cantor Harry Lubow in 1953. In the 1950s, the wave of Jewish migration from Chelsea brought many families who joined the new congregation, where they found a comfortable and energetic Conservative community. Vigorous Sisterhood and Brotherhood organizations welcomed the newcomers with cultural, social and athletic events.

In 1955, a new temple building was designed by renowned architect Pietro Belluschi, a leading figure in the Modern movement and then the dean of architecture and planning at Massachusetts Institute of Technology. Rabbi Meyer Finkelstein (1955–57), Rabbi Peretz Halpern (1957–77), Rabbi Sanford Shanblatt (1977–96), Rabbi Earl Kideckel and Rabbi Neal Lovinger later led the temple's religious life in the inspiring structure that included a massive, domed wooden drum over the sanctuary, studded with stained glass.

Early in the millennium, Presidents Michael Rosenbaum and Marla Gay joined with the leadership of Temple Beth El to begin the process of merging the congregations. Temple Beth El and Temple Israel had served their

Temple Israel Chanukah celebration with Hebrew School children dressed up as Maccabees.

separate congregants in Swampscott and Marblehead for over thirty-five years, and while they were located only one hundred yards apart, they had differences in congregational traditions that required masterful and sensitive resolution. By the spring of 2005, the charters were signed for the creation of a new congregation—Shirat Hayam. During the year of transition, services were held at Temple Israel until the building and a portion of the temple property were sold to the Town of Swampscott in 2006.

TEMPLE SINAI

In May 1953, a group of former members of Swampscott's Temple Israel met to discuss establishment of a new Conservative synagogue and religious school. Led by Dr. Louis Barron, Harold W. Cohen, Dr. Morris Cohen, Adrian Comins and Harry Weinstein, the new Temple Sinai became a reality in the next few months. Located in a large house on Atlantic Avenue

in Swampscott, the temple chose Rabbi Dov Zlotnick and Cantor Charles Lew as its first spiritual leaders.

The congregation grew quickly. In 1961, founding member Eli Cohen, a passionate philanthropist and visionary, and Samuel Backman purchased more than eleven acres on a rocky point overlooking the Atlantic Ocean on Atlantic Avenue in Marblehead. There on Community Road a new Temple Sinai building was constructed. (Subsequently, the Cohen Hillel Academy and the Jewish Community Center of the North Shore built neighboring facilities on the same site.)

The arrival of Rabbi Meyer and Ruth Strassfeld in 1965 signaled the beginning of Temple Sinai's leadership in the areas of civil rights and Jewish social responsibility. The role of women in temple life was vigorously debated, and by 1975 women were counted in daily minyans and ascended the bimah to receive aliyot. Jessie Lipson became the temple's first female president in 1987. Rabbi Jonas Goldberg took his post in 1989 and with his wife Chelly fostered the spirit of closeness and caring that characterizes the congregation today. The current president of the congregation is Allen Kamer.

Religious education has always been a cornerstone of Temple Sinai's mission. It is generally understood that a debate over the religious school at Temple Israel fed the desire for a new institution, which then became Temple Sinai. Youngsters from the early days recall their experiences in the first house on Atlantic Avenue, with classes and holiday services led by Mr. Simon Young and Miss Ida Yanover. (Mr. Young and Miss Yanover taught at Temple Israel before Temple Sinai was established.) The temple is currently home to the North Shore Hebrew School, whose students include those from Temple Sinai, Temple Shalom in Salem, Congregation Ahabat Sholom in Lynn and those whose families are not affiliated with a synagogue.

TEMPLE EMANU-EL

In April 1954, ten families came together to plan the first Reform synagogue on the North Shore. Headed by Alfred M. Gross Jr., its first president, the new congregation first held services in the parish house of the Old North Church in Marblehead, then in the Odd Fellows Hall. Religious school classes were held at the Marblehead YMCA.

When Martin Katzenstein became the first rabbi in October 1955, services were being held at the Baptist church near the monument in Swampscott. It was a proud day when the newly built Temple Emanu-El was dedicated on Atlantic Avenue in Marblehead in September 1959. During the next year, Rabbi Katzenstein resigned to take a position at Harvard's School of Religion. (Sadly, he died soon afterward.) Robert Shapiro, a charismatic and enthusiastic young rabbi, led the growing congregation for the next thirty years. Rabbi David Meyer currently leads the congregation, assisted by Rabbi Debra Kassoff.

Throughout the years, Temple Emanu-El's congregation has taken an active part in local and international social action projects. These have included the resettlement of Vietnamese families and adoption of Vietnamese orphans, serving food at My Brother's Table, collecting and distributing children's books for "Reach Out and Read" in Lynn, collecting food for the Marblehead Food Pantry, environmental cleaning, making blankets for the special care nursery at North Shore Children's Hospital and making and selling bracelets for the victims of the Darfur genocide.

The Brotherhood group has often invited local political candidates to speak, and through the efforts of past president Bitsy Bitman, the annual jazz concert brings well-known jazz artists to Marblehead. One of the highlights of the last fifty years was the appearance of Isaac Bashevis Singer before a sold-out crowd on a Saturday evening and among the religious schoolchildren on a Sunday morning in the early 1970s.

In 1995, Jerry Somers, a member and past president of Temple Emanu-El from Swampscott, became chairman of the board of the Union of American Hebrew Congregations (UAHC) and served a two-year term. Currently known as the Union for Reform Judaism, the URJ is the national congregational arm of the Reform movement.

CHABAD LUBAVITCH OF THE NORTH SHORE

Sent with his wife, Leah, as an emissary team from the Orthodox worldwide Chabad-Lubavitch movement, charismatic young Rabbi Yossi Lipsker opened the Chabad Lubavitch Center of the North Shore above the White Hen Pantry on Humphrey Street in Swampscott in May 1992. As a rabbinical intern, he had first met members of the Jewish community when he led Shabbat services at the now disbanded

Orthodox Congregation of the North Shore, held at the home of Harry Fielding on Seaview Avenue in Marblehead. The energy, enthusiasm and deep Jewish knowledge of the young couple, parents of six children, attracted growing numbers of the area's Jews, and in 1999, the Chabad Community Shul opened its doors in the former Church of the Seventh Day Adventist on Burrill Street in Swampscott. This was originally the Baptist congregation that lent its building to Marblehead's Temple Emanu-El in its earliest years. A beautifully carved wooden ark, installed with great difficulty and care when it was brought from former Congregation Chevra Thilim in Lynn, stands magnificently on the bimah. Today, the Chabad—which welcomes everyone in the Jewish community of the North Shore for celebrations of Shabbat, holiday observances, life cycle events and educational activities—operates a Hebrew School, children's camps and the Jew Crew for teenagers.

CONGREGATION SHIRAT HAYAM

When the charter of Congregation Shirat Hayam ("Song at the Sea," an appropriate phrase from the Bible given the synagogue's location) was signed on May 19, 2005, it marked the merging of Temple Beth El and Temple Israel, which had existed side by side in Swampscott for decades. It also signaled the beginning of a hopeful new era for the Conservative movement on the North Shore. With the departure of Rabbi Weinsberg of the former Temple Beth El, who had agreed to lead the new congregation for the first year, Mark Friedman, Shirat Hayam's first president, led the search for a new rabbi ready to embrace the many challenges of the newly merged congregations.

Rabbi Baruch HaLevi and his family arrived in July 2006, pledging to reinvigorate the Conservative congregation and expand its reach to meet the needs of people at every stage of life. True to his mission, the congregation grew from 400 families to more than 550 in the following two and a half years. An array of innovative approaches to prayer based on the "synaplex" model—including a renewal minyan, a yoga minyan and *nosh* and *drash* Torah study with guest scholars, as well as a traditional service—brings more than 300 people to the synagogue every Shabbat. Led by Director Jed Filler, all of the children from Shirat Hayam's Center for Jewish Education, which holds classes on Shabbat, join the congregation, Cantor Emil Berkovits and Rabbi

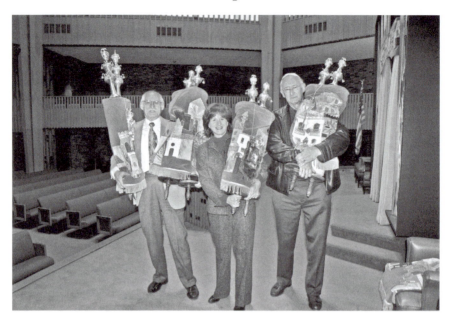

In 2005, Temple Beth El and Temple Israel in Swampscott merged to form Congregation Shirat Hayam (Song at the Sea). Holding the Torahs, in preparation of bringing them from Temple Israel to the new congregation, are Cantor Emil Berkovits; Helaine R. Hazlett, president Temple Beth El, 2002–5; and Mark Arnold, president Temple Beth El, 1990–93. *Courtesy Herb Goldberg Photography.*

HaLevi for a closing "Ruach Rally" of joyous guitar music, tambourines and song, followed by an inclusive festive lunch sponsored by members of the congregation.

The synagogue houses a preschool and the Center for Jewish Education, as well as programs for teens, adult Jewish education, a Chesed committee of volunteers that help congregants in need, women's choral and Rosh Chodesh groups and a group of members who are not "officially" Jewish: Spiritual Friends of CSH. In February 2009, a group of forty-four went to Cuba on a humanitarian mission, carrying a repaired and refurbished "kosher" Torah as a gift to a congregation in Havana, as well as medical supplies and clothing. A building committee is pursuing plans to provide the increased space necessary for this energized and flourishing congregation.

Swampscott and Marblehead

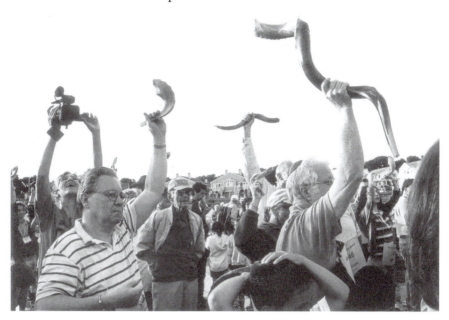

In the fall of 2006, 1,600 people assembled at Phillips Beach in Swampscott to watch as 804 people simultaneously blew shofars, breaking the previous record of 400 established in the *Guinness Book of World Records* the previous year. The event, known as "the Great Shofar Blowout," was sponsored by the Robert I. Lappin Foundation, and it enabled the North Shore Jewish Community to regain the record it had previously set in 2004, when 386 shofars were sounded. The Lappin Foundation sponsored fourteen training sessions and handed out free shofars from Israel. *Courtesy Herb Goldberg Photography.*

Swampscott and Marblehead Jews at a *Tashlikh* ceremony. *Tashlikh*, meaning "casting off," is a long-standing Jewish practice performed on the afternoon of Rosh Hashanah, the Jewish New Year. The previous year's sins are symbolically "cast off" by throwing pieces of bread or a similar item into a large natural body of flowing water—in this case, the Atlantic Ocean. The practice is derived from the biblical passage recited at the ceremony: "You will cast all their sins into the depths of the sea." *Courtesy Herb Goldberg Photography.*

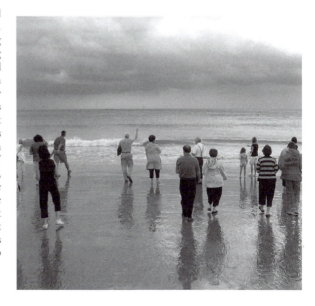

JEWISH INSTITUTIONS

JEWISH REHABILITATION CENTER

Founded in 1945 as the Jewish Convalescent Home for the poor, needy and sick, including wounded veterans of World War II, the old house on Washington Street in Lynn changed its name to Jewish Home for the Aged when its mission changed in 1951. When it became clear that the old structure could no longer meet the needs of a growing population of elders, a campaign to build a new home was undertaken. Under the leadership of President Harry Stahl, Herbert Gold, Meyer Kirstein, Dave Fermon, Sam Klivansky, Dr. Samuel Levine and Henry Gibbs, land was found on Paradise Road in Swampscott, funds were obtained and ground was broken for a new facility, the Jewish Rehabilitation Center for Aged of the North Shore, in 1970.

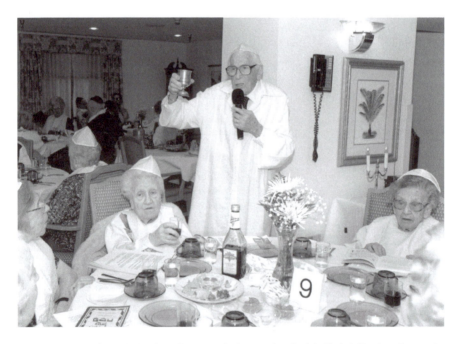

Cantor Morton Shanok leads a Passover Seder at the Jewish Rehabilitation Center in Swampscott, where he served as religious cultural coordinator in his later years.

From the day it opened its doors to having eighty residents in 1972, the Jewish Rehabilitation Center has been meeting the needs of the North Shore's elderly with an increasing array of services and expansions. These included adding a second floor in 1977, construction of an addition to house the Shapiro-Rudolph Adult Day Center (named for philanthropists Sam Shapiro and Lou Rudolph) for elders living at home in 1985 and a major renovation in 1995. Recognizing that elders have a range of needs that do not require skilled nursing, the JRC built Woodbridge Assisted Living in Peabody in 1996.

Now called Jewish Rehabilitation Center for Living, the Swampscott facility is home to 176 residents, including one floor devoted to dementia patients and thirty short-term rehabilitation beds. Under the direction of CEO Steven Neff, in 2008 the JRC added home care to its array of services that have enhanced the quality of life for seniors on the North Shore.

ELI AND BESSIE COHEN HILLEL ACADEMY

Located first on Blossom Street in Lynn in the same building as the venerable Lynn Hebrew School, the North Shore's first Jewish day school (known then as the Lynn Hebrew Day School) began to teach its earliest students in kindergarten and first grade in 1955. By 1962, the school had grown in size and had become Hillel Academy of the North Shore, moving to Temple Sinai's former building on Atlantic Avenue in Swampscott under the guidance of Principal Robert Marcus. In the 1970s, the school, which now exceeded one hundred students, moved to the former Temple Israel, where it remained until 1985, when ground was broken for a new building next to the Jewish Community Center in Marblehead on land that realtor Samuel Backman and philanthropist Eli Cohen had secured for the Jewish community years before. At that time, the name of the school, under the able leadership of the late, beloved principal, Bennett Solomon (1979–87), was changed to honor the Cohen family.

Serving students from twenty-two North Shore communities, Cohen Hillel Academy offers a challenging curriculum that includes general academic subjects along with Hebrew language and Jewish studies. Today, the head of the school is Ken Schulman, who leads a cadre of dedicated teachers of students in kindergarten through grade eight.

Bessie and Eli Cohen, noted philanthropists and community leaders for whom the Cohen Hillel Academy on Community Road in Marblehead is named.

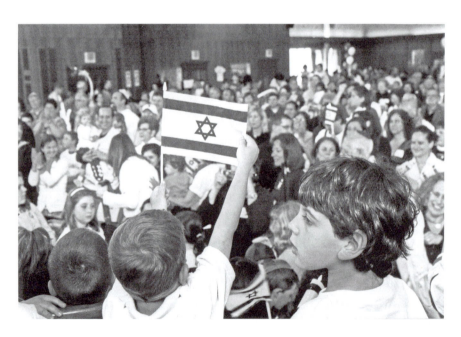

The State of Israel, established in May 1948, observed its sixtieth birthday with a jubilant celebration in May 2008 at Congregation Shirat Hayam in Swampscott.

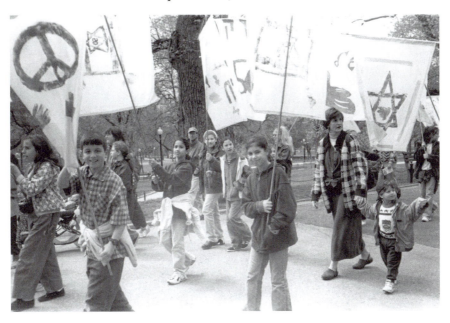

Students at Swampscott's Cohen Hillel Academy marched in a peace rally supporting the State of Israel.

JEWISH COMMUNITY CENTER

In 1957, as the Jewish population shift from Lynn to the suburbs progressed, the Jewish Community Center, which had been located in Lynn since 1911 when it was the YMHA, began to conduct extension programs at Temple Israel in Swampscott. During the next year, land was purchased in Marblehead overlooking the Atlantic, and by the summer of 1960 the outdoor pool was opened for JCC members. This enabled Camp Simchah to initiate activities on the beautifully situated Marblehead campus. Construction of the new building in Marblehead began with groundbreaking on October 19, 1969, after a three-year fundraising campaign. Three decades after the Lynn YMHA moved to 45 Market Street in Lynn, the North Shore Jewish Community Center was dedicated in November 1972, as membership tripled in those thirty years, from 400 to nearly 1,300, including many new Americans from the former Soviet Union. Not long afterward, a decision was made to open on Saturday afternoons for recreational activities, a controversial decision that evolved after much discussion with area rabbis and members under the leadership of Jacob Segal.

The North Shore JCC was on the cutting edge when it developed the first JCC infant-toddler program in the country in 1978. Bea Paul, director of the preschool, saw the need for quality childcare as more and more young mothers returned to work after childbirth. The program has been filled to capacity ever since.

On May 22, 1982, ten short years after the building was completed, a Mortgage Burning Celebration was held at a black tie dinner dance, the seventy-first annual meeting. Ernie Weiss had led the campaign, with Bob Lappin leading the charge. Soon after, under the leadership of President Michael Eschelbacher, a JCC extension was opened at Syms Plaza in Peabody to serve the Jewish community that was growing in that area.

At the seventy-seventh annual meeting in 1988, Helaine R. Hazlett was installed as the first female president of the center. The JCC had caught up with the times. Since then there have been many respected female presidents. In 1997, under the leadership of Joseph Sontz, $2.3 million was raised to improve and expand the building. For the five thousand members, a new early childhood wing was built, and four classrooms, a women's health center and a new and expanded fitness center with state-of-the-art exercise equipment were added.

In 2005, a group of twenty-two families with foresight and passion for the JCC established a planned giving program, the Market Street Legacy. Three years later, with a change in the financial landscape, President Steve Hamelburg embarked on an in-depth feasibility study to secure the future of the center. Serving approximately five thousand members, the JCC continues to provide a central role in fulfilling the needs of its membership. The Marblehead building houses twelve preschool and infant/toddler rooms, a pool, a gym, two fitness centers, two health centers and a dance studio. The outdoor complex includes a pool, tennis and basketball courts, a ball field and summer Kindercamp for young children. A one-hundred-acre Middleton campus, a venue for many outdoor activities, is the home of Camp Simchah and various specialty camps.

The Jewish Community Center of the North Shore has changed from a gathering place for the immigrant population of Lynn at the turn of the twentieth century to a place that serves the total community—Jews and non-Jews—of the twenty-first century. As the JCC of the North Shore approaches its 100th anniversary, it continues to provide the community with programs and services that embrace all ages while enhancing personal, social and physical development of its membership.

CIVIC, CULTURAL AND POLITICAL ACTIVITY

DOLPHIN YACHT CLUB

An increasing number of Jews in comfortable financial circumstances after World War II appreciated Swampscott and Marblehead's proximity to the ocean, especially the opportunities for boating in an area known for its busy, well-situated harbor. After several incidents of discrimination that denied Jewish yachtsmen access to essential services in Marblehead harbor, a group that included Nathan Cohen, Hy Jaffee, Morris Jaynes, David Kunian, Irving Mann, Ben Myers, John Rimer, Arthur Rubino, Dr. Adolf Sandberg,

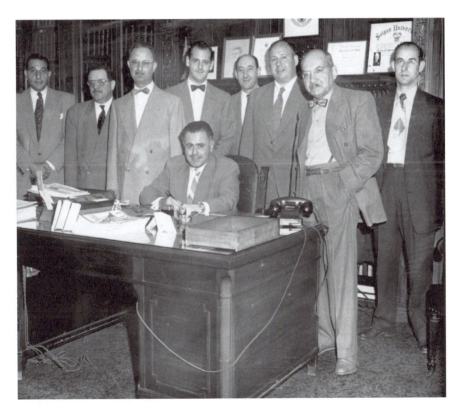

The Dolphin Yacht Club was established in Marblehead in 1951 after arranging to purchase the property in 1950.

Dr. Nathan Silbert, Harry Simons, Phenny Smidt, Leo Sonnabend, Robert Weiss and B. Fred Yoffa met to establish a club that would be open to all "without regard to race, color, or national origin." In 1950, a "straw" purchased property on their behalf, and the next year the Dolphin Yacht Club was established on the Marblehead waterfront with Harry Weinstein as the first commodore.

Today, the Dolphin Yacht Club, true to its Article of Association, has more than four hundred members of many religious backgrounds. Jews and non-Jews enjoy dining overlooking the harbor and participating in the social events of a busy boating season. The current commodore is Vin Conte.

Clubs and Camps for Kids

Some will remember the clubs and youthful associations that Jewish teens enjoyed in the community. In the '50s and early '60s, the boys may have been "Stags" (whose sole purpose was to play poker on Friday nights and wear cool blue jackets with gold lettering) or "Reggies" (who preferred royal blue with red lettering). AZA (Alpha Zadik Alpha, one of the B'nai B'rith Youth Organizations for boys) instilled camaraderie among Jewish youth with social, athletic and community service activities. Girls may recall the high school sororities of Delta Kappa (whose members wore crossed gold pins on a blue grosgrain bow), Sigma Iota (pins on a blue ribbon bracelet) and Alpha Lambda (white buttons on a blue ribbon bracelet). A DVD in the archives of the Jewish Historical Society of the North Shore shows the 1960 Alpha Lambda installation of officers, held at the Hawthorne restaurant in Lynn, with Reggie Robinson Weinstein and Roberta Weiner giving the presidents' report. Most groups provided opportunities to develop social consciousness and to hone leadership skills. All provided an environment in which Jewish teenagers could be together to form friendships for a lifetime.

Many women who grew up in Swampscott and Marblehead remember BBG (B'nai B'rith Girls, the feminine equivalent of AZA) and the Shoshanos of Senior Young Judea. Janet Saltz Freedman, a past president of BBG, and Edye Comins Baker, a past president of Senior Young Judea, recall the conferences, meetings, services and events that provided leadership opportunities for teenage Jewish girls. Janet remembers a BBG leadership camp in Starlight, Pennsylvania, and a conclave she attended with AZA member Artie (Israel) Horowitz. Mr. Horowitz, originally from Wakefield,

Swampscott and Marblehead

Massachusetts, became a famous playwright and founder of the Gloucester Stage Company. BBG raised money for Jewish charities as well as CARE and UNESCO.

The calendar of events for the 1959–60 season of the Shoshanos Senior Young Judea included ten evening programs (book reviews, Israeli dancing, guest speakers and a hair and make-up show), nine special events (a Chanukah party, ad-book campaign, bowling, model seder and horseback riding) and five fundraisers (a cake sale, fashion show, variety show and "BIG" dance). The point was to keep the teenagers engaged in a Jewish world, with Jewish friends and adult Jewish oversight. Edye recalls a November Sunday when eighteen girls met at the Blue Line subway stop in Revere and went to Zionist House in Boston for Israeli dancing and singing.

Starting in the mid-1950s, many Jewish children and teens in Swampscott and Marblehead attended overnight summer camps (resulting in fond memories for some and nightmares of homesickness for others). Among the overnight camps, most still in business today, were Camp Avoda in Middleboro; Camp Bauercrest in Amesbury; Camps Brunonia, Rapputak, Lakeridge Manor, Kingswood and Naomi in Maine; Belvoir Terrace in Lenox; Camp Ramah in Palmer; Camp Yavneh and Camp Alton in New Hampshire; Camp Young Judea in Amherst; and the Eli and Bessie Cohen Camps: Tel Noar, Pembroke and Tevya. Day camps included Camp Menorah and the JCC Camp Simchah in Middleton, located on land donated by Lynn philanthropist Louis Barrett.

In today's culturally integrated society, the North Shore Teen Initiative hopes to help teenagers reconnect with the values and relationships that sustained generations of the North Shore's young people in the past. In May 2008, a task force of Jewish professionals and lay people led by Jerome Somers was awarded nearly $1 million by the Jim Joseph Foundation. The three-year pilot study seeks ways to engage, support and inspire Jewish adolescents through social networking, community service and experiential Jewish learning. Adam Smith is the Initiative's first executive director, and Ina-Lee Block is president of the board of directors.

Culture and Commerce

As Jewish women moved to the suburbs of Swampscott and Marblehead in the mid-twentieth century, many found satisfaction in their affiliation with Jewish organizations, as most did not work outside the home. Among Swampscott-Marblehead Hadassah's missions was raising funds for hospitals in Israel. The Hadassah Thrift Shop, which closed recently, was a popular destination for both bargain hunters and closet cleaners. B'nai B'rith Women planned programs and delivered gifts to servicemen at the Soldiers' Home in Chelsea, as well as supporting youth services and women's rights and combating prejudice. National Women's Committee members of Brandeis University met in study groups and raised money for the library at the university in Waltham. True Sisters bought the first mammography machine for Salem Hospital and donated over $300,000 for cancer detection and therapy until the organization's demise in 2007. Members of Juvenile Aid, originally organized to make layettes for Jewish babies, focused their efforts on raising money for college scholarships. ORT (an organization that supports schools, rehabilitation and training programs for Jews worldwide), the Sisterhoods of Temples Beth El, Israel, Emanu-El and Sinai, Women's Division of the Jewish Federation and the Women's Auxiliary of the Jewish Rehabilitation Center are among the numerous organizations that have benefited from the energy and dedication of the women of Swampscott and Marblehead. Today, the majority of these organizations are still vital and active, with revamped schedules to accommodate the majority of women who now work outside the home.

After the desecrations of Temple Emanu-El and the JCC in 1989, the Anti-Defamation League has had a major presence on the North Shore, meeting regularly in Swampscott and Marblehead. The ADL North Shore Advisory Committee holds an annual dinner with well-known speakers, sponsors an interfaith Seder every year, hosts an annual Law Day Breakfast to recognize law enforcement and legal professionals and implemented the "No Place for Hate"® campaigns in several cities and towns on the North Shore to fight prejudice and bigotry.

The Marblehead Festival of Arts has benefited from the enthusiastic and dedicated work of photographer Herb Goldberg, artists Nordia Kaye and Ruth Rooks, Milton and Arlene Bloom and Howard Rosenkrantz. Major civic projects, including the Swampscott Library addition, were spearheaded by Carole Schutzer. Sylvia Belkin of Swampscott has long

been on the forefront of community preservation, conducting research and leading projects to restore Swampscott's historic fishhouse and its town hall, the former residence of Elihu Thompson, one of the founders of General Electric.

Before World War II, the majority of Jewish professionals—physicians, dentists and attorneys—had offices in Lynn, close to hospitals, the courthouse and their patients and clients. As the Jewish population migrated to Swampscott and Marblehead, numerous doctors and lawyers followed, many to the new "glass" office building erected in Vinnin Square in the early 1970s.

The Jewish residents of Swampscott and Marblehead traditionally headed to Lynn to buy goods at the many shops owned by Jewish merchants, primarily in the vicinity of Central Square and Summer Street. By the 1960s, Swampscott and Marblehead had their share of Jewish merchants, too. Cele Taylor, Bob Rose's Designer Shop and Morton's (later to become Loehmann's), all in Swampscott, were in the vanguard of new fashions in Swampscott. For home decorating, the place to go was Norman's Paint and Wallpaper in Vinnin Square, still run by Norman Jepsky with his son Bob. In Marblehead, Bruce Hamlin's was the place to buy shoes and Thelma Finger of RSVP Thelma, who began in her home in Swampscott, advised you about your milestone invitations. You may have shopped at Colbert Liquors and bought flowers at the Marblehead Super Market, affectionately known as "Louie's." The Finklepearl sisters sold gifts from their house on the Marblehead-Swampscott line, and the Golden Eagle gift shop on Humphrey Street in Swampscott morphed into Natalie's when Natalie Belostock moved her gifts out of her home.

Colorful and outspoken Eva Peretzman and her brother, Curly, who commuted from Dorchester, operated Mar-Scott Market at the corner of Humphrey Street and Puritan Road in Swampscott from 1950 to 1965. They specialized in high-quality fruits and vegetables, as did Elliot's Fruit Basket. (Fruit of the Four Seasons, started by Sam Convicer in Marblehead, continues this high quality today.) Alan Nataupsky owned Alan's Meating Place for top-quality meats in Marblehead, and in Swampscott Myron (Mailie) Schneiderman and Bill Weinstein ran Colonial Meat Market, next to Sherman's Flowers on Humphrey Street. If you were hungry for deli, you might go to the Cutting Board, located in Vinnin Square for a short time. As of early 2009, the only Jewish deli in either town was Evan's on Smith Street in Marblehead.

POLITICAL AND PROFESSIONAL PERSONALITIES

Since settling in Swampscott and Marblehead, Jews had been involved in local politics, helping their candidates win election to office. It was not until the 1960s that Jews began to run for office themselves. Swampscott town moderator Martin (Bozie) Goldman has held his post since 1989. Carole Shutzer, named by the Massachusetts Commission on the Status of Women as an "Unsung Heroine" in 2008, is a former member of the board of selectmen (the first Jewish woman), former library trustee and president of the Friends of the Swampscott Public Library. Richard Bane, Jim Rudolph, Marc Paster, Paul Levenson, Peter Waldfogel and Larry Greenbaum have served on the board of selectmen, where Adam Forman and Robert Mazow currently sit. In the late 1960s, Florence Alexander (former state representative Larry Alexander's mother) served as library trustee. Jack Paster was elected town clerk/collector. The school committee benefited from the dedication of Dr. Merrill Feldman, Judith Lippa, Shelly Sackett, Cindy Taymore, Sandy Rotner and Richard Feinberg. Currently, Phillip Rotner holds a school committee seat. Kenneth Shutzer was a longtime chairman of the zoning board of appeals, where Andy Rose and Harry Pass are currently serving. Dr. Lawrence Block served as chairman of the board of health for many years. Many others, including Nelson Kessler, Gene Barden, Arthur Goldberg, Jeff Blonder and Neil Bernstein, have served on important town boards. Lesley Stahl of *60 Minutes* and *CBS News* fame grew up in Swampscott.

In Marblehead, Arnold Alexander was the first Jewish member of the board of selectmen, serving from 1969 to 1993, many of those years as the board's chairman. Helaine R. Hazlett was the first Jewish woman to be elected to public office, serving on the school committee from 1984 to 1993 and then on the board of health from 1997 to the present. Jackie Belf-Becker joined her colleague on the school committee in 1988. She later won a seat on the board of selectmen. Peggy Blass was elected library trustee in 1991 to the present. Attorney Carl Goodman served on the board of health from 1987 to 2009, with a break to sit on the board of selectmen in 1990 and 1991. Dr. David Becker was first elected to the board of health in 1990 until he retired in 2008, followed by his son, Dr. Todd Belf-Becker. Attorney David Stern also served many years on the zoning board of appeals.

Swampscott and Marblehead

In 1976, Larry Alexander won a seat on the Marblehead Planning Board, and in 1979, he was the first Jew from Swampscott-Marblehead to be elected to the state legislature, in which he served until 1990. In 2007, State Representative Lori Ehrlich became the first Jewish woman to be elected to the Swampscott-Marblehead district, which also includes Lynn's Diamond District. She is currently in her first full term, after filling an unexpired term.

From their beginnings in Swampscott and Marblehead at the turn of the nineteenth century, when they were part-time residents and newcomers who received chilly receptions as outsiders, Jews have made substantial contributions to life in their interfaith neighborhoods and towns, while retaining separate Jewish institutions and interest groups. This has not always been easy, and small niches of discrimination still exist, but Jews in Swampscott and Marblehead can be proud of their success in managing the multiple identities that accompany being Jews in America.

Edye Comins Baker, Helaine Roos Hazlett and Barbara Tolpin Vinick are members of the board of directors of the Jewish Historical Society of the North Shore.

PEABODY

Peabody, previously the town of Danvers, became the town of Peabody in 1868 and the city of Peabody in 1916. Named for famed philanthropist George Foster Peabody, the city of Peabody, for most of the late nineteenth century and into the 1970s, was one of the world's foremost leather producers, with over one hundred tanneries. It was the jobs that the leather industry provided that led to the influx of immigrant Jews, as well as Greeks, Poles, Turks and Portuguese, which provided the labor force necessary for a thriving industry. The following was written by M. Irving Herbster, Avrom J. Herbster and Irving Sacks, with additional material provided by Alan Pierce and Paul Ordman on behalf of the Congregation Sons of Israel.

EARLY HISTORY

The first known Jewish settlers in Peabody were Louis Karelitz and Charles Halpert, who came from Russia in 1896. At the turn of the twentieth century, there were about 15 Jewish families in Peabody. By 1909, the number increased to about 100, drawn to Peabody from Russia, Poland, Lithuania and Germany, many of them experienced leather workers in their home countries. These early residents were joined by others before and after World War I and the Russian Revolution. By 1920, there were about 200 Jewish families in Peabody, increasing in the next twenty years to 350 as fortunate families left Germany and Poland before the Nazi Holocaust.

Synagogues

On November 15, 1909, eighteen men met at the home of Louis Glichouse on Buxton Street and planted the seed of Congregation Sons of Israel. Charter members included Samuel Rossen, Louis Glichouse, Barney Rubin, Samuel Slotnick, Harris Abelovtich, Hyman Israelovitz, Louis Altshuler, Jacob Edelstein, Harris Goldberg, Louis Karelitz, Robert Cohen, Sam Gilman, Jacob Gorenstein, Abraham Kaplan and Abraham Perlman. The material assets of these men were small, but their hearts were big, their determination and courage were strong and their vision far-sighted.

After the charter was given to the congregation by the Commonwealth of Massachusetts on December 14, 1909, new members began to join at twenty-five cents per month in dues. With continued efforts to raise funds, land was purchased in 1912, and a contract was made with Samuel Goldberg to construct the synagogue for $6,500. Although Mr. Goldberg was not the lowest bidder, he was the only member of the congregation among the bidders and later became one of the presidents. When more money was needed to complete construction, the problem was solved by selling a corner of the land at Sanborn Street, delaying the installation of a steam boiler and shortening the length of the balconies in the interior. The latter proved to be a good idea, as it permitted more light from the windows and a broader view of the artistic front of the building. Until the completion of the synagogue, services were held at the Red Men's Hall on Foster Street where the Peabody Hebrew School was first established. Reverend Nathanson was the teacher.

The High Holiday services of 1913 were the first to be held in the synagogue, with Reverend Nathanson as the cantor. He was also the *shochet* (ritual slaughterer) for the congregation, charging five cents per chicken at the butcher's and ten cents if he had to do this at a private home. When the synagogue was first constructed, the bimah was in the center of the sanctuary, with a walkway between the bimah and *Aron Hakodesh* (Holy Ark), in the Orthodox manner. A large brass chandelier hung from the ceiling, with moveable chairs for the men and benches in the balcony for the women.

In 1925, the sanctuary was rebuilt by installing the new bimah and Ark, the ones that exist today, as well as chandeliers donated by David and Sadie Kirstein and Myer and Ida Kirstein and new pews donated by Max and Rhoda Korn. The pews were controversial, as some people had contracts for seats facing the congregation, which were removed by the new configuration. Mr. Korn had to have the pews rebuilt.

Peabody

The first president of the congregation was Samuel Rossen, followed by Frank Hershenson, David Kirstein, Elihu Hershenson, Morris Isaacson, Samuel Goldberg, Allen S. Levy, Irving Sacks, Sidney Barosin, Hyman Sogoloff, Harvey Chandler, Bernie Horowitz and, as of 2009, Sumner Greenberg. After Reverend Nathanson, the first spiritual leader engaged by the congregation was the Reverend Maurice Ordman, who also served as the cantor, the *shochet* and *mohel* for the Jewish community. He was followed by the Rabbis Chaim Essrog, Irving Perlman, Samuel Langer, Arthur Oles and, from 1953 to 1962, Rabbi Noah Goldstein. M. Irving Herbster served as ritual director and spiritual leader from 1962 to 1998. Bart Perlman followed him and then Avrom J. Herbster, and today, Bernie Horowitz is ritual committee chair. The shamosim have been Jacob Morris, endearingly called the "Rebelle," Abraham Silverman, Morris Talkowsky, Reverend Issac Miller and Chaim Weisman, who was also the Torah reader from 1962 to 1979.

An important function of the congregation was the Hebrew School, which, with all of the excellent teachers, committees and the Sisterhood, added to its history thanks to the leadership of beloved teachers Moshe and

Paul Ordman and his brother, Avrom J. Herbster, unveil a plaque in commemoration of their father, the late M. Irving Herbster, a longtime leader in the Jewish community and ritual director of Congregation Sons of Israel. The chapel and social hall were dedicated in his name on October 20, 1996.

Hilda Shiffman. No child of the Hebrew School could forget the center's custodian, Jack Figueroa. The "Fig," a burly yet lovable man, was able to exercise control of the sometimes unruly boys by grabbing the offender in a head lock and applying a brisk rub of his sand paper–like jowl stubble on the cheeks of a misbehaving student. This would produce both evidence of the misbehavior and the promise of future decorum.

Congregation Anshe Sfard was known as the Little Shul, perhaps due to its small size relative to Congregation Sons of Israel (the big shul) around the corner or due to its location at 7 Littles Lane just off Peabody Square. In 1913, the shul was established by recent Russian immigrants who initially held services in rental space on Main Street. They then purchased a former house stable and moved in during the spring of 1916. Anshe Sfard was a "Russicher" shul, whose congregants came primarily from Russia, whereas Congregation Sons of Israel was a "Littvisher" shul, whose membership originated primarily in Lithuania. Both shuls had similar Arks created by the same woodcarver, and both had balconies upstairs for the women.

Congregation Tifereth Israel was founded in 1922 by seven Sephardic Jews who emigrated from Constantinople, Turkey. (The Touro Synagogue in Newport, Rhode Island, is the only other Sephardic synagogue north of New York.) The ancestors of Sephardic Jews were forced out of Spain and Portugal by the Inquisitions that began during the reign of King Ferdinand and Queen Isabella of Spain in 1492. During the fifteenth and sixteenth centuries, close to a half million Jews were murdered, and several hundred thousand were forced to convert to Catholicism. Many more were expelled or fled to all parts of the Ottoman Empire, where they were generally granted refuge. They developed their own language, Ladino, sometimes called Judeo-Spanish, with additions from Greek, Armenian, Turkish and other languages of the countries to which the Jews fled.

The roots of the Peabody Sephardic community began in 1911 with the arrival of Don and Rebecca Eskenas and Meyer and Regina Bevotar. The founders also included the Pernitchi, Savy, Behar, Yonis, Gibely, Hasday, Havian, Fermon and Erera families. For many years, Rabbi Dov Pikelny was Tifereth Israel's spiritual leader. Today, the congregation is led by Rabbi Howard Kosovske.

After World War II, interest in Conservative and Reform Judaism increased. In 1958, the Conservative Temple Ner Tamid was founded, with Leon Steiff as the first president. Services were conducted at the Cy Tenney Hall in West Peabody, in the Anshe Sfard Synagogue and at the Tifereth Israel

Children examine a Torah scroll during Simchat Torah services, a celebration marking the conclusion of the annual cycle of Torah readings and the beginning of a new cycle. *Courtesy Herb Goldberg Photography.*

Synagogue on Pierpont Street. Finally, in May 1965, the temple dedicated its own edifice on Lowell Street with Rabbi Ralph DeKoven. Rabbi Abraham Morhaim served as spiritual leader for twenty-nine years until 1996 and was succeeded by Rabbi Leonard Muroff. Rabbi David Klatzker is the current rabbi. Cantor Sam Pessaroff, who passed away in 2008, served the temple as cantor and teacher for over thirty years and was well known as a mohel in the Greater Boston area and beyond. The temple maintains an active Hebrew School, Women's League, Men's Club and a large and active USY (United Synagogue Youth) group.

At the same time that Temple New Tamid was founded in 1958, the Reform Temple Beth Shalom was established. Edward Hoffman was its first president, and Rabbi Richard Safran its first spiritual leader, followed by Rabbi Morris Kipper. Services were first conducted at the Cy Tenney Hall, then at the St. Vasilios Recreational Center on Tremont Street, and at the Hebrew Community Center until the temple was built off Lowell Street and dedicated in November 1965. Beth Shalom continued to grow and, as one of the few Reform temples in the area, attracted members from many

Temple Beth Shalom was established in 1958 as the Jewish population in West Peabody and surrounding towns increased. There was a need for a Reform congregation, and Temple Beth Shalom has served the Jewish community for over fifty years. The congregation is currently led by Rabbinic Intern Dan Berman and Cantorial Soloist Colman Reaboi. Lisa Cohen currently serves as temple president.

surrounding communities. Today, Daniel Berman is spiritual leader and rabbinic intern, and Colman Reaboi is cantorial soloist.

Chabad Lubavitch of the North Shore, affiliated with the Lubavitch Chassidic movement, established a Chabad Center in recent years that is currently led by Rabbi Mechemiah and Raizel Schusterman. The Chabad Center houses a Hebrew School and runs a summer day camp in the same building as the JCC on Pine Street.

MERCHANTS, MANUFACTURERS AND BUSINESSES

Meanwhile, some other Jewish residents became merchants and manufacturers. Peabody was known worldwide as the Leather City. In its heyday, there were over one hundred tanneries or leather-related businesses. Similar to their experience in the shoe industry in nearby Lynn, Jewish immigrants were drawn to Peabody for jobs in the shoe and leather

factories, and entrepreneurial spirit soon took root. In short order, many of these businesses became Jewish owned. Among the leading Jewish-owned and Jewish-run leather firms were: Peabody Embossing (Louis Meyerson), Mincovitz Leather Sales, Ossoff Leather, Pearl Embossing and Allen Leather (Allen and Edward Pearl), Central Buffing (Robert and Sidney Pierce), Prager Leather, Bond Leather (Murray Rain), Remis Leather, R.L. Leather (David Rosenfelt), Korn Leather, Salloway and Salwin Leather, Shawmut Tannery (Allen and Charles Scholnick), Smidt Leather, Barney Singer Leather, Kirstein Leather, Strauss Tannery, Stahl Finish, N.H. Matz Leather, Mann Leather—and, perhaps, a dozen or more others. Other prominent families in the leather business were Agoos, Behar, Bycoff, Camenker, Castleman, Edelstein, Edinburg, Fermon, Freedson, Fromer, Goldberg, Hershenson, Isaacson, Kaplan, Katzman, Klivansky, Lampert, Lerner, Limon, Lippa, Osman, Palais, Rabinovitz, Salloway, Savy, Silverman, Sogoloff, Steinharter, Tanzer, Tarlow, Weisman, Zabar and Zion.

Among the earliest merchants were Louis Karelitz and Jacob Remis in furniture; Michael Berstein's Bakery; Ellis Elmont, Aaron Klivansky, Samuel Komarin, Abraham Kaplan and Harry and Max Herman with shoe stores; David Rosenfelt and Joe Levin in haberdashery; and Sidney Lippa in transportation. Simon Rosen started in the shoe repair business and later repaired bicycles, radios and hardware. Samuel Rafey was in hardware; M.P. Stone and Barnet Smidt in coal; Louis Waisberg, Abraham Hoffman, Harry and Sam Bacherman, Solomon Herbster, Azriel Spatrick and Michael Shaktman operated the first grocery stores; and Sam Pitcoff ran Sam's Lunch on Foster Street for many years. Some of the other more well-known Jewish-owned businesses around Peabody Square were Goldstein's Shoe Store, Gordon Realty, Alpers Men's Store, Hoffman's Meat Market, Weisberg's Meat Market, Sheinhert Kosher Slaughterhouse, Karelitz Furniture and Mizner's Tailor Shop. Samuel Goldberg constructed the Sons of Israel Synagogue in 1913, and many houses in the East End. Samuel Marron built many of the houses in South Peabody. Charles B. Smidt built the houses on Smidt Avenue and several apartment buildings in Peabody and Salem. Samuel Tanzer had a blacksmith shop in the early years. Sol Droitiner was a real estate agent. Louis Glass, who ran a grocery store, served often as an interpreter for many who had not yet learned the English language. Charles Halpert and Raymond Bacherman operated steamship travel agencies. Samuel Chiplovitz was a cattle farmer. Morris and Nathan Goldstein and Samuel

Ainbinder were butcher shop owners, and Morris Beres and Zundel Lampert were the first fruit and vegetable peddlers.

The earliest professional men were Attorney Elihu A. Hershenson, who began practicing law in Peabody in 1912, and Dr. Harry Halpern in the general practice of medicine, and Dr. Leavitt was the first Jewish dentist.

At the end of World War II, the population of Jewish families stood at about four hundred. As men returned from the armed services, many housing developments with affordable residences for young families sprang up in Peabody in the 1950s. The city's population doubled within a decade, as did the numbers of Jews. Engineers, technicians and other young professional men made their homes here, and by 1960 there were about eight hundred families.

Today, the center of Jewish life has shifted from the central part of the city to West Peabody. In the last decades, corner drugstores—such as Ordman's, operated by Harry Ordman—and retail stores—such as Remis Furniture, operated by David Remis—have been replaced by regional and national chain stores that draw people from surrounding communities to Peabody's North Shore Mall. From 1983 to 1999, Larry Goldman and Scott Bucklin ran Goldbuck's Deli in West Peabody. Larry Levine's Kosher Meats may be the only retail establishment today selling an exclusively kosher product in the North Shore area. The leather industry that supported so many Jewish families came to a virtual end long ago, with just a few small factories left today.

ORGANIZATIONS

Among the earliest organizations in Peabody was the local branch of the Workingmen's Circle (the Arbeiter Ring), established in 1907. Founded in 1892 in New York by immigrant Jews from eastern Europe, the Arbeiter Ring was inspired by Socialist ideals to improve the lot of the workingman in America through mutual aid and education. One of its pillars was the preservation and transmission of Jewish heritage through Yiddish. In the early 1920s, the Peabody branch established the Arbeiter Ring Schule, where Yiddish was taught for the next thirty years.

Another early group was the Independent Order of B'rith Abraham, a now defunct fraternal lodge established in 1913 and active until 1930. The same year, the Popular Credit Union was incorporated by David Rosenfelt and others. Providing financial assistance to new immigrants, it was among the first credit unions in Massachusetts. The proliferation of other credit

unions and banks led to its closing in the 1960s. In 1916, the Maple Hill Cemetery Association was organized, and a burial ground was dedicated on North Central Street. Organizers included Samuel Goldberg, Samuel Rossen, M. Cohen and Charles B. Smidt. A separate interfaith section of the cemetery was established recently.

Since the beginnings of Jewish communities in America, women have assumed leadership roles in organizations devoted to community service and education. Peabody was no exception. The Ladies Auxiliary of the Peabody Hebrew School, first located at Congregation Sons of Israel, was a very active group from its inception in 1917. Among its organizers were women who used their husbands' names, as was the custom at the time—Mrs. Max Korn, Mrs. Louis Karelitz, Mrs. Philip Weinblatt, Mrs. Frank Hershenson and Mrs. Regina Strauss. The Ladies Auxiliary of the Congregation Anshe Sfard was founded under the leadership of Mrs. David Herman, Mrs. Abraham Bazer and Mrs. Michael Shaftman. A number of charitable organizations were established and served local needs for many years. The Hebrew Ladies Aid Society, led by Mrs. Louis Glass and Mrs. Barnet Smidt, was the largest of the charitable organizations that met the needs of the community for decades. Before the birth of the State of Israel, the Jewish Pioneer Women raised funds for the labor movement in Palestine. More recently, local chapters of Hadassah, ORT and B'nai B'rith Women were established and continue to benefit Jews locally, nationally and internationally, some having merged with other local chapters.

In October 1939, a dream of Jewish leaders in this city for many years was realized with the dedication of the Hebrew Community Center on Washington Street, made possible by the work of David Kirstein, Max Kirstein, Max Korn, Manahan P. Stone, the Ladies Auxiliary of the Hebrew School and many others. The first president was Samuel Rafey, who died before the building was dedicated. He was succeeded by Dr. Irving Winer. Other presidents were Elihu A. Hershenson, M. Irving Herbster, Bernard J. Alpers and David Remis. Rabbi Chaim Essrog was the center's first executive director. The year 1939 was a landmark year in Peabody, as in addition to the Community Center, the United Jewish Appeal was launched to help Jewish pioneers entering Palestine before the founding of the State of Israel. Among the first leaders were Max Korn, David Kirstein, Max Kirstein, David Rosenfelt, Barnet Smidt and Louis Meyerson. The Peabody United Jewish Appeal is now part of the Jewish Federation of the New Shore, with offices located in Salem.

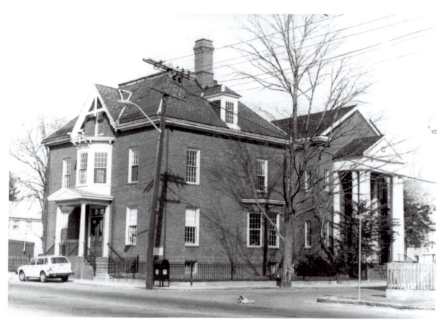

The Peabody Hebrew Community Center was for many years located at 42 Washington Street, Peabody. The center housed the Hebrew School for Congregation Sons of Israel, and its social hall was the site of many functions, including Bar Mitzvah and Bat Mitzvah celebrations. Various youth groups, including AZA and Boy Scout Troop 97 met regularly at the center. The Hebrew Community Center closed in the early 1970s, and shortly thereafter, the North Shore Jewish Community Center, now known as North Suburban Jewish Community Center, was established in West Peabody.

COMMUNITY RESOURCES

The Hebrew Community Center closed in the 1970s and was replaced by a new institution in 1979. Youth groups that met there—Louis D. Brandeis Chapter of AZA, Young Judea girls' group and Troop 97 (formerly Troop 7), a primarily Jewish Boy Scout Troop—had already faded and closed in the 1960s. The new North Shore Jewish Community Center was relocated to West Peabody, where the Jewish population was now based. First located at Syms Plaza on Lowell Street, in 1994 the center moved to its present Pine Street location and became known as the North Suburban Jewish Community Center, serving Peabody and surrounding communities.

Many other organizations continue to flourish. Hadassah, originally Peabody based, now includes members from the surrounding cities and towns and has over four hundred members. B'nai B'rith Peabody lodge

merged with the Beverly lodge, but the members still annually run a popular food concession booth at the Topsfield Fair to raise needed funds for national programs. ORT still maintains its presence in the area and is part of the eastern Massachusetts chapter. The Jewish War Veterans Post 220 and Auxiliary continue, and its members are active in veterans' affairs and the Peabody Veterans Council and participate in the Peabody Memorial Day parade and other activities. Maple Hill Cemetery continues to serve the needs of older, and now newer, Jewish families in Peabody. Recently, it established a separate, interfaith section in the cemetery.

Peabody's Jewish community sent 30 men to World War I and about 150 men and about 10 women to World War II, of whom 7 made the supreme sacrifice—Sidney Arons, Harold Kirstein, Jacob Stahl, Morris Trabach, Abraham Verner, Ralph Yonis and Louis Wisemen. In 1939, Joseph Salloway, a veteran of World War I, was instrumental in organizing in Peabody Post 220 of the National Jewish War Veterans and serving as its first commander. With its Ladies Auxiliary, the post continues, serving disabled veterans by frequent visits to various hospitals in the eastern part of the state and

The Peabody B'nai B'rith Lodge No. 2765 for many years has maintained a booth serving various Jewish foods at the Topsfield Fair.

Woodbridge, an assisted living facility located off Lynnfield Street in Peabody, is a part of the Jewish Rehabilitation Center of the North Shore. Here, many of the residents are depicted with entertainers brought in for one of Woodbridge's many afternoons or evenings of entertainment for its residents.

participating every year in the Peabody Memorial Day Parade, the Peabody Veterans Council and other activities.

In 1982, the Holocaust Center Boston North was established for the study and remembrance of the Holocaust. Located for many years at the McCarthy School, it was moved in 2001 to the Peabody Institute Library. Under the guidance of founders Harriett Wacks and Sonia Weitz, a Holocaust survivor who serves on the governing council of the United States Holocaust Memorial Museum, the center now encompasses education about other genocides and human rights.

In 1997, the Jewish Rehabilitation Center of the North Shore, located in Swampscott, opened Woodbridge, a state-of-the-art assisted living facility, in a wooded area of Lynnfield Street. Woodbridge has eighty-two apartments and serves kosher meals.

Peabody

PUBLIC OFFICIALS AND PUBLIC SERVICE

Jews have held public office in Peabody through the years, primarily city solicitors and school community members. The first was Attorney Elihu A. Hershenson, a member of the school committee, who was elected to the city council in 1926 and subsequently became city solicitor from 1935 to 1938. Attorney George Ankeles was elected to the city council in 1933, and from 1946 to 1951 was appointed city solicitor by Mayor Leo F. McGrath. Attorney Abraham Ankeles held the office of city solicitor from 1956 to 1961 and, in 1964, was appointed special justice of the District Court of Peabody by Governor Endicott Peabody. The first Jewish woman in politics was Attorney Cynthia Fields, who was elected to the school committee in 1958 and served until 1962. Edward Bacherman and Gilbert Rosenthal served on the school committee throughout the 1960s. Attorney M. Irving Herbster held the office of city solicitor from 1962 to 1967, and Harry Sherr was appointed the first ombudsman of the city in the late 1960s.

Jews continued to make a contribution to the civil life of Peabody. Among the city officials who have held elected office since 1968 are Councilors David Harris, Shepard Remis, Barry Feinstein and Judith Selesnick; and Library Trustees Albert Cohen, Mark Titelbaum, Judith Wolfe and Robert Shaw. Bernard Horowitz, director of human services, is responsible for operation of the Health Department. Jewish residents are members of city boards and committees and are represented in the schools, police and fire departments.

PEABODY PERSONALITIES

A number of Jewish people from Peabody have become well known in the arts. Katherine Locke appeared on stage and film from the 1930s to the early 1950s. Doris Halpern Schwerin is the author of *Diary of a Pigeon Watcher* (1976) about growing up in Peabody as the daughter of the first Jewish doctor. Sidney Goldfarb, a poet and playwright, wrote a poem about his native city in the 1960s. Lennie's on the Turnpike on Route 1, owned by Lennie Sogoloff from the 1950s to the 1970s, featured jazz greats like Count Basie, Woody Herman and Stan Getz and comedians including Mort Sahl, Professor Irwin Corey and a young local upstart, Jay Leno. More recently, Jonathan Sacks is an orchestrator for many popular films,

and Gary Gulman is a rising stand-up comic, having made a number of national television appearances.

For the past fifty years or more, photographer Roy Wallman has documented most of the important events in Peabody and the entire North Shore. He has generously donated many of his photographs to the Jewish Historical Society of the North Shore.

The historic Washington Street home of Dr. Benjamin Salata, a prominent dentist for many years, was recently given to the Peabody Historical Society by his wife, Celia, and restored as the Osborn-Salata House.

Beginning as a small town, Peabody first made its mark as the leading leather city of the United States. Now a suburban household community and the home to the largest retail mall north of Boston, Peabody has retained remarkable ethnic diversity. The Jewish community has added many sustaining strands to the vibrant tapestry that is Peabody, Massachusetts.

SALEM

S alem, world famous for its witch trials at the end of the seventeenth century, was founded in 1626. The settlement—it was far from a city in those days—was named Naumkeag, a word in the language of the local Penacook Indians meaning "fishing place." The settlers preferred the name Salem, derived from "Shalom," which is, of course, the Hebrew word for peace.

SALEM'S JEWISH HISTORY

Judy Axelrod Arnold and Judy Simon Remis

Early records show that some residents of Salem in the late 1600s were Sephardic Jews from Spain and Portugal whose families had escaped the infamous Inquisitions of the fifteenth and sixteenth centuries. By the mid-1800s, Jews from Russia and Germany were arriving. Greater numbers of Jews from Russia and eastern Europe settled in Salem beginning in the 1880s as immigrants fleeing czarist oppression and seeking opportunities for better lives reached the "Goldene Medina" of their dreams. Their numbers climbed steadily in the years before and after World War II.

Around the turn of the twentieth century, two centers of Jewish life had developed in Salem—the Derby/Essex Street area, which drew the lion's share of Jewish immigrants, and the Boston Street area bordering Peabody. The Boston Street Jews opened a shul at 165 Boston Street. Among the congregants were descendants of the original Sephardic Jews who had come to Salem in the earliest years.

In 1898, a formal charter was issued to Congregation Sons of Jacob to serve the Derby/Essex Street Jews. Forty-one persons formed this new congregation. The next year, the congregation secured land on Buxton Road in Danvers for a cemetery, which is still in use today. Services were conducted at various rented locations, including 4 Derby Square, until 1903, when the congregation purchased the Calvary Baptist Church at the corner of Essex and Union Streets, diagonally across Essex Street from the Hawthorne Hotel. Its first president was Max Winer, an immigrant from Lithuania, who founded Winer's Specialty Shop on Lafayette Street, one of the first retail clothing stores in Salem. Rabbi Joseph Jacobson was called to Salem to occupy the pulpit of the congregation.

In March 1911, Congregation Sons of Jacob held its second annual Purim Ball. Practically all of the representatives of the social and business life of the local Jewish community, along with many out-of-town guests, were present at the affair, which was held at historic Hamilton Hall for many years. Even Mayor Howard made an appearance. The event was organized by a number of the leaders of the congregation, including President Joseph L. Simon, Henry Rogers, Max Schribman, Robert Rogers, Samuel Aronson, Louis Gershaw, Max Goldberg, Harry Winer, Samuel Grass, Charles Gotchman, Sam Share, T. Morris and Simon Kaplan. The men wore tails, the women evening gowns. Walsh's ten-piece orchestra furnished the music, and refreshments were served. Proceeds of the ball were devoted to several worthy charitable projects.

Alterations on the original church building, including the addition of a balcony for women, allowed the building to serve as a house of worship for the next forty-nine years. During those years, the congregation maintained an active religious school, a Sisterhood formed in 1931 and a Brotherhood as well. The vestry served as a school meetinghouse and social hall.

Sara Posner, who grew up in what is now Temple Shalom back in the days when it was Congregation Sons of Jacob, described the old shul:

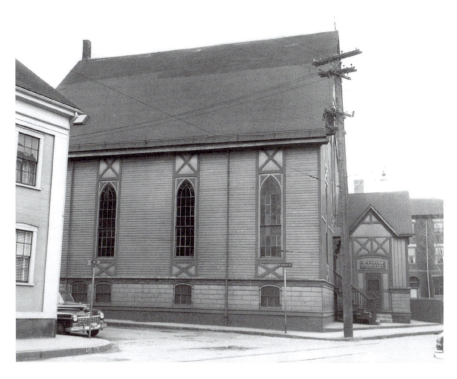

Temple Shalom's predecessor was Congregation Sons of Jacob, charted in 1898. From 1903 through the 1940s, the shul was located at the corner of Essex and Union Streets, across from the Hawthorne Hotel.

I remember an austere wooden building, its wide staircase leading directly to a cobblestone street. The interior of the structure was without ornamentation so that its focal point became the Holy Ark. Services were almost completely in Hebrew, and the decorum was not always reverent, so that, at times, Shalom Aleichem would have felt at home in this transplanted East European setting, where prayer was frequently punctuated by Yiddish conversation.

In the years before World War II, as people became more affluent, the Jewish population gradually shifted from the Derby Street neighborhood of the old synagogue to South Salem. In 1936, a site was acquired by Max Goldberg at the corner of Lafayette Street and Ocean Avenue, which served as the Jewish Community Center of an expanding Jewish population for sixteen years. During World War II, the building was also used by local civic groups, including the Red Cross and Civil Defense. In

1940, the congregation acquired real estate on Lafayette Street adjacent to the property that it already owned.

In 1947, Congregation Sons of Jacob welcomed Rabbi Abraham Kazis, who became the first Conservative rabbi to occupy a pulpit in Salem. During the following year, the congregation affiliated with the United Synagogue of America, the Conservative arm of American Judaism. A fundraising campaign culminated in construction of a new house of worship, renamed Temple Shalom, dedicated on December 12, 1952.

By the mid- to late 1950s, Salem's Temple Shalom boasted 450 families, representing an estimated Jewish population of two to three thousand—the high-water mark of Jewish Salem. Former Salem mayor and judge Sam Zoll, the highest Jewish elected official in Salem's history, said that Salem was home to only four hundred Jews when he ran for mayor in 1969.

Forty years later—in 2009—there are an estimated one thousand Jews who call Salem home, but many of them are elderly couples or singles

December 12, 1952, marked the dedication of a new synagogue in Salem, Temple Shalom, located on Lafayette Street. The synagogue is still in active use today.

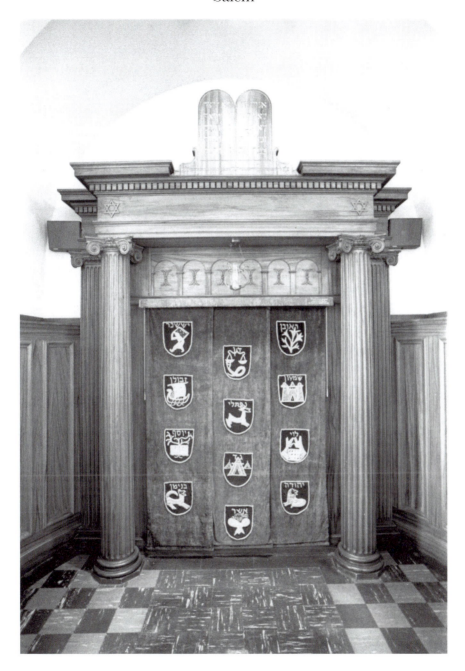

The Holy Ark, built in 1903 for Congregation Sons of Jacob, was moved in 1952 and installed in the Daily Chapel at Temple Shalom on Lafayette Street.

As did many synagogues, Temple Shalom had an active temple Brotherhood. In 1959, the brotherhood presented "a modern minstrel," *Shalom'z A-Poppin'*.

(widows and widowers) living in condominiums and apartments in the Vinnin Square area, many who moved there from Marblehead, Swampscott and other North Shore communities and have no strong Salem affiliations.

JEWISH RETAILERS

The earliest Jewish merchants were William Filene, who opened a retail store in 1856 at 156 Essex Street, and David Conrad, who founded Ladies Goods at 163 Essex Street at about the same time. Both merchants moved their businesses to Boston in the next few years. Filene's became a famous department store and a household name that exists today, while Conrad's became a smaller specialty store that survived until the mid-twentieth century. In 1867, Conrad became an alderman, the city's first elected Jewish officeholder.

Salem

Many Jewish emigrants from eastern Europe began their merchandising careers in Salem as peddlers with sacks on their backs, graduating to horses and buggies and, later, as they became more successful, opening shops. These included Sam and Benny Axelrod, their cousin Robert (Reuven) Axelrod and Max Winer—all in the early years of the twentieth century. Many of these early Jewish-owned homegrown retail businesses flourished. As the transportation hub of the North Shore, the city became a shopping mecca in the 1930s and '40s. All of the trains and buses in the area converged in Salem. Steam engines would rumble into the historic old Salem train station at what is now Riley Plaza on Washington Street.

In a personal reflection penned for the fiftieth anniversary of the Salem synagogue, Sara Posner summed up the condition of Salem's Jewish entrepreneurs this way:

> *When the temple on Lafayette Street was officially dedicated in 1952, Salem was a thriving mercantile center with both large and small stores running the length of what is now the Essex Street walking mall. Many of these stores were owned by Jewish merchants who were members of the congregation. The membership also included doctors, lawyers, and accountants, those in the leather and shoe trades, and small businessmen such as cobblers, furriers, and tailors.*

Walking toward Washington Street from the Hawthorne Hotel on Essex Street, the main shopping drag, shoppers seeking out Jewish merchants would have encountered Bessie's Dress Shop, the Rose Bonnet millinery shop and the Royal women's clothing shop. Above the Royal was Laura Greenberg's Pattee Anne shop for children's clothing, a few doors down from the North Shore's largest Jewish retailer, the Empire, part of the store chain owned by Salem brothers Sam and Benjamin Axelrod. The brothers, remembers former mayor Sam Zoll, were "leaders in the Jewish and non-Jewish community." Ben's son, Leonard, helped diversify and expand the business and became a leading local Jewish philanthropist, donating the Axelrod Wing at the Salem Hospital and the walkway from Essex Street to Charter Street, adjacent to the new Peabody Essex Museum.

Farther down Essex Street were Buddy Esses's Buddy's for baby furniture and clothing; Rooks, M.H. Baker's, Jack's, Newmark's and Bixby's, all selling women's clothing; Your Boys Store; Herman's Boot Store; Miller Music; L.H. Rogers for women's high-end designer clothing; Salem Army & Navy

Store (owned by Norman Barron, who later cofounded Marshall's); and Boston Leader for women's accessories.

Continuing across Washington Street on Essex, our shoppers would encounter Edward Adelman's Salem Smoke Shop, R.A. Day women's clothing shop, R. Axelrod and Sons dry goods store and Lann's Florist.

Nearby Washington Street, across from the post office, was the original site of Jerry's Army & Navy Store—outfitters of generations of Salem's children—Giblee's, Louis Baker's and Fisher's Men's Store for men's clothing and Louis Feingold's Salem Kiddie Shop. On the corner of Washington and Essex Streets, diagonally across from the church that became Daniel Low's department store, was T.R. Kerr furniture store.

Jewish merchants radiated out from Essex to other nearby streets. On Central and lower Lafayette Street were Dottie and Joe Kessler's Children's Store, Hy Silver's Electrical Supply Equipment, Lamper's shoes, Carmen-Kimball travel agency, Eva's Hat Shop and Selbert Jacobson's haberdashery. On Front Street, later the site of the Jewish Federation of the North Shore, were Jake Share stationery, Beaulieu & Linsky paint and wallpaper, Freedman's hardware, Barron's Butcher Shop and Jake Goldstein's clothing shop.

In the 1950s, to remedy a traffic-snarling grade crossing at the intersection of New Derby and Washington Streets, Governor Paul Dever appropriated funds to finance what became Salem's version of the Big Dig. The station was demolished, the tracks were moved underground and a tunnel was constructed to exit farther up Washington Street. The construction disrupted traffic in and out of the city for several years. As a result, many merchants were forced out of business, their customers fleeing to the North Shore Shopping Center in Peabody, which opened in 1958. Salem's downtown never completely recovered from the twin blows of the railroad disruption and the Peabody shopping center.

JEWISH BUSINESSES

Retailing, of course, was not the only way that Jews earned a living. Jewish business owners of the early twentieth century included manufacturers Max Korn and Max Silverman, whose leather company spawned a dozen or more ancillary leather firms, most of them in the Boston Street area bordering Peabody. S. Bernstein and Son manufactured men's clothing on Front Street.

Salem

Several decades later, merchants and shoppers often converged for lunch at Gerber's Delicatessen, a hotbed for discussions and rumors about politics and unions, on Washington Street near the corner of Essex. Other Jewish-owned delis were Sushel's and Lander's, both on Central Street. Weinshel the butcher was located in the same neighborhood as tailors Nagel and Wiggetman. Another Jewish tailor, Morris Orloff, was located on St. Peter Street, and two others were on Essex—Waller's and Pekin's.

Broadway had Shaw's eggs and poultry (run by Leo and William Shoer). The popular open-air market between Front and Derby Streets at Derby Square was home to a host of Jewish businesses, including Zundel Lambert's fruits and vegetables and Pofcher's Fish Market. Then there were fruit peddlers who first sold off trucks and then at fruit and vegetable markets near the old Town Hall plaza. The largest of these, Salem Food Land, started by Les and Al Oppenheim, later became Cressey-Dockham, a major area food wholesaler.

In other areas of Salem were Morry's Cleaners on Bridge Street, owned by Meyer Finkelstein, and on Leach Street Ben & Harry's Economart, a small grocery store owned by Ben Linsky and Harry Rosenfeld. On Phillips Street in North Salem was a junkyard owned by Isaac Talkowsky. Saul and Ben Ablow's Salem Paper occupied the space now housing Roosevelt's Restaurant on New Derby and Central Street. Where Domino's Pizza now reigns supreme on Canal Street was Ted Simons's Ted's Tire Co. Also on Canal Street was Salem Glass, owned by Saul Gilberg and today by his daughter, Lori Miller, and her adult children.

Then there were the real estate magnates. Much of the property on the block where the Elizabeth Montgomery *Bewitched* statue stands (now designated Lappin Park) was owned by John Lappin, father of philanthropist Robert I. Lappin. Across from Salem City Hall on Washington Street was a block of commercial real estate owned by the Shribman family. The Goldberg family's name remains on one of their real estate holdings—the former wallpaper store on the corner of New Derby and Washington Streets, opposite the new Loft condominiums. David Frye was another prominent Salem businessman with large real estate holdings.

With a workforce of 2,500, mostly French Canadians, Pequot Mills, in the neighborhood of the Point, was Salem's largest employer and the largest manufacturer of sheets and pillowcases in the nation. When the huge mill moved south in 1953, Bob Lappin bought the facility, renaming it Shetland Properties after the Shetland brand of vacuum cleaners that was his core

business. He leased the building to a variety of businesses, invested heavily in real estate and became for more than forty years the most important benefactor of local Jewish organizations. Other Jewish-owned businesses included the Berkowitz family's Seacrest Beverages on Highland Avenue, the Collier family's Allied Lumber, Maynard Axelrod's Maynard Plastics, Lipsky Movers, Avrum Levin's Spring Pond Ice Company on Boston Street and Dexter Furriers, owned by the Allen family.

Politics and Community Involvement

For much of its early history, Salem was a Republican town. In 1867, David Conrad served on the Salem Board of Aldermen, according to an article that appeared in the "Man About Town" column of the *Salem News* in November 1911. J.L. Simon served as chairman of the Salem Republican

Salem merchant and businessman H. Simon, in the front row with a black top hat, is standing next to Justice Louis D. Brandeis, along with other Jewish merchants and members of the community in this undated photo taken near the Salem Common.

Massachusetts governor Francis Sargent congratulates Salem mayor Samuel Zoll, his wife Marjorie and children Barry, Rachel, Risa and Cheryl on his appointment as justice of the district court for the Commonwealth of Massachusetts.

Committee during the administration of President Taft in the early years of the twentieth century—before the influx of immigrants shifted the city to the Democratic column.

Almost half a century later, in 1957, Democrat Sam Zoll was elected to the Salem City Council, becoming council president in his second year. He later served as state representative, mayor (1970–73), district court judge, chief judge of the district courts and chair of the state's Labor-Management Committee for Public Safety. Describing how he became a successful politician, Judge Zoll wrote:

> *My Dad, for health reasons, was unable to work for a long period, so all through grammar school, high school and college I was the paperboy in North Salem. At one point, at my peak, I hit 400 papers every day, and close to 1,100 papers on Sunday. I knew everybody; I was part of their family. I never went any place. I was there every day on time, and there was never any money missing from the doorstep. So when I came home from the*

service and decided to run for a ward Council seat, my mother said to me, "I thought you were going to be an accountant." She didn't want me to get hurt. My opponent, who didn't know me because I had been away for a few years, said, "Kid, you never have a chance." Little did he know how deep my base went. I just made it—by 191 votes. People were great to me.

Judge Zoll also described a prophetic moment with Peabody's Dave Kirstein at High Holiday services:

He [Mr. Kirstein] was up on the bimah soliciting contributions, and his secretary, who used to be out in the front entry, was recording. He would go up and down the pews. I knew him only because he was at services on Kol Nidre—this was before he lost his son in World War II—and I'd see him around the congregation. He called my father's name. I had never had a conversation with him other than to say, "Hello Mr. Kirstein." I was fourteen years old. My father says, "Fifteen dollars." "How about a little more, Joe?" My father pauses, you know. He didn't have much more at that point. "Okay, Dave, twenty-five dollars." I'm sitting next to my father, and Mr. Kirstein says, "Joe, thank you, thank you. You know, some day your son is going to be mayor of Salem."

From the 1960s on, Jews took an active role in the civic life of the city, serving on municipal boards, as bank officers and trustees and as volunteers at the Peabody Essex Museum and Salem Hospital. Gerald Posner was one of several founders of the Salem-based *Jewish Journal* in 1977 and went on to serve as its publisher on and off for more than a decade. A few Jews even became well-respected local athletes. Fred Axelrod was a boxer and also a linebacker for Dartmouth's football team. Eddie Wineapple was recruited for the 1930 baseball season by the Washington American League baseball club.

JEWISH PROFESSIONALS

The first Jewish physician in Salem was Dr. Max Lesses, who lived next to the Salem Common. He was followed by dozens, now hundreds, more. Dr. Alan Freedburg was a well-known dermatologist of the pre–World War II period. Dr. Gregory Alexander and Dr. Harry Freedberg were among the

first Jewish physicians admitted to practice at Salem Hospital, now part of a greatly expanded North Shore Medical Center. Among the most prominent physicians in the postwar years was Dr. Israel Kaplan, who later became the first Jewish chairman of the Salem Board of Health. His name is honored by the thirty-year-old Shaughnessy-Kaplan Rehabilitation Hospital, associated with the North Shore Medical Center.

The first Jewish dentist may have been Meyer Winer, a 1912 graduate of Harvard Dental School and father of the late dentist Richard Winer, former president of the North Shore Jewish Historical Society. J.L. Simon's son, Harry, was a prominent local attorney who served as city solicitor and, along with Al Pitcoff, served on the planning board. Other prominent lawyers of the early to mid-twentieth century were Hy Marcus, Al Zetlan and brothers Lenny and Barry Berkal.

JEWISH SOCIAL LIFE

In the period between 1910 and 1920, ballroom dancing gained great popularity. Salem boasted several dance halls, notably the Greater Salem Dancing School in Odell Hall across from the district court. According to Judge Zoll, "You never went there with a girlfriend. That's where you went to meet the right girl. There was dancing from 7:30 to 9:30 p.m., a dance contest till 10:30, and they gave prizes. There was a mix of Jewish and non-Jewish youngsters there. My father's specialty was the five-step *chotisse*, known today as the foxtrot."

In the early years of the twentieth century, one couple who met on the dance floor used to look forward to meeting every week. After several months of dancing, the young lady got impatient that her companion showed no sign of being ready to "pop the question." So one night she surprised him by saying she was going to be married. Alarmed, he asked, "Who are you marrying?" "You," she answered. He quickly agreed. The couple did indeed marry and raised four children.

Kernwood Country Club has been central to the social life of the North Shore's affluent Jews for more than a century. Founded in response to the exclusion of Jews from the area's established country clubs, the club's history goes back to 1914, when conversations among Louis Kirstein, Joe Liebman, Jesse Koshland and Al Kaffenburg led to negotiations to purchase a beautiful parcel of land in North Salem. This was where, in 1844, Colonel Francis

In 1914, the Kernwood Country Club was established in North Salem. A beautiful golf course, tennis courts, restaurant and full country club facilities have been enjoyed by area Jews for almost one hundred years.

Peabody purchased land for a summer home that he called Kernwood. The golf course was laid out by architect Donald Ross, who designed many of the nation's finest courses. Two tennis courts were built on the west side of the old homestead, enclosed by hedges. First named Elm Hill Country Club, it was later renamed Kernwood Country Club after the original name of Colonel Peabody's property. Louis E. Kirstein was the first president from 1914 to 1918. Though only six holes were completed for the opening, more than one hundred prominent Jewish residents of Boston and the vicinity, many of them summer residents of the North Shore, were elated to play at the new golf club.

Salem Willows, a historic waterfront park that included amusements, opened in 1858, drawing young working-class single people and families throughout the nineteenth and twentieth centuries, including its share of the Jewish community. Its popular Charleshurst Ballroom, now the Willows Casino, was operated for many years by Charles Shribman. Among the luminaries who played there were Duke Ellington, Count Basie and Louis Armstrong.

The annual Jewish Heritage Day, featuring Jewish food, music and games, was a popular summertime event in downtown Salem in the 1980s and 1990s, drawing thousands of visitors to the city. A highlight one year was the sight of Dr. Israel Kaplan alighting from a ship at Pickering Wharf dressed as a humble immigrant. In later years, as crowds dwindled and the city came under financial pressures, the event was moved to the grounds of Temple Shalom and then phased out.

JEWISH FEDERATION OF THE NORTH SHORE

Before the turn of the twentieth century, as waves of needy Jews made their way to Boston from eastern Europe and beyond, members of the local Jewish community already in place organized an array of social, health and educational services to help the new immigrants. In 1895, Boston's Jews,

Massachusetts senator Paul Tsongas, on the left, meets with noted area business leaders and philanthropists Howard Rich, Robert I. Lappin, Executive Director of the Jewish Federation of the North Shore Gerry Fermon, Peter Lappin and Ralph Kaplan.

realizing that cooperation in regard to fundraising and charitable activities would be desirable, created a centralized umbrella organization that later became known as Combined Jewish Philanthropies. Now numbering nearly two hundred around the country, this was the first such organization in the United States.

In the same spirit, the Jewish Federation of the North Shore was created in 1938 in Lynn to fulfill the community's need for a central agency to be responsible for unifying the good work done by local institutions and also to address the needs of Jewish communities overseas. After moving from the JCC in Marblehead, the Federation currently maintains offices at East India Square in Salem, across from the Peabody Essex Museum. The Federation's annual Community Campaign helps to support Jewish agencies that encompass the North Shore's twenty-two Jewish communities—Cohen Hillel Academy, the Holocaust Center North of Boston, the Jewish Community Centers in Marblehead and Peabody, Jewish Family Service of the North Shore, the Jewish Historical Society of the North Shore, *Jewish Journal Boston North* and *Mikvah B'not Yisrael* at Congregation Ahabat Sholom in Lynn—as well as vital services in Israel and around the globe.

JEWISH JOURNAL BOSTON NORTH

The idea of a free, biweekly Jewish community newspaper was first suggested in the 1970s at a Federation retreat that focused on "Planning the Ideal Jewish Community." The paper was to provide a sense of connectedness that was felt essential for a progressive and vital Jewish community. In 1977, the first edition was published with $20,000 of Federation funds. First editor Gerald Posner, a pivotal force in the *Journal's* history, led early volunteers up the steep learning curve of the newspaper business.

In the early years, the *Journal* won several prestigious awards. In 1984, Barbara Wolf, editor from 1983 to 1991, won the Smolar Award, Jewish journalism's highest honor, for "Recovery and Restitution," a two-part series describing the conflict over German reparations in financing the young State of Israel. In 1991, the *Journal* and Barbara Wolf received the Simon Rockover Award for excellence in feature writing.

In November 1981, Dr. George S. Freedman, a psychiatrist, lifelong resident of Marblehead and former president of the Jewish Federation of the North Shore, submitted an editorial cartoon to the *Jewish Journal* of the North

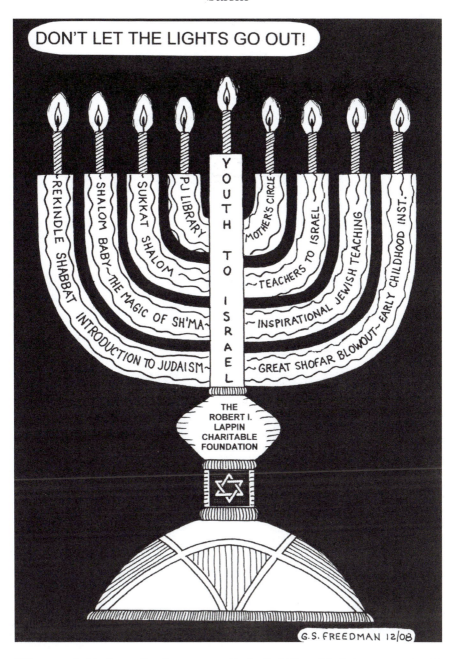

This cartoon by Dr. George Freedman appeared in the *Jewish Journal* depicting a menorah, with its branches, illustrating the various charitable endeavors of the Robert I. Lappin Foundation.

Shore. A self-taught artist who always enjoyed drawing, he did not intend to launch a series. But as readers responded enthusiastically, one cartoon led to another. Providing insightful punctuation to news of the day, as well as commemoration of noteworthy people, holidays and other special occasions, Freedman's cartoons have continued uninterrupted in every issue of the biweekly paper for more than twenty-five years. As he recently stated:

> I feel very fortunate to have fallen into the habit of drawing editorial cartoons. The whole process has been a source of great satisfaction for me. I have tried hard to maintain a standard of fairness and honesty from the perspective of a free and democratic society. I believe a successful cartoon distorts the facts just enough to make the facts more real.

Despite both reader and professional acclaim, the paper struggled financially and in the early 1990s was nearing bankruptcy. The Federation stepped in, and Gerald Posner again took the reins. By 1995, Gerald was appointed publisher, the name of the paper was changed to the *Jewish Journal/North of Boston* and the paper regained some financial footing. Today the paper's publisher is Barbara Schneider and Bette Keva is editor.

In its thirty years, the *Journal* has not shied away from controversy and has provided a vigorous forum for opinions and divergent philosophies. "What Price Pesach" by Rosa Rasiel concluded, "Kosher foods are expensive throughout the year, but at Passover prices rise like a nine-egg soufflé." In "Moving to the Neck," arguably the most influential article ever to appear, Editor Alan Jacobs exposed restrictive real estate practices that kept Jews from being shown homes for sale on Marblehead Neck. Some realtors denied the practice and threatened to sue the *Journal*, but suddenly barriers fell. Within a year, Jewish families found homes on the Neck. In 2008, the paper launched an online Internet version. The paper remains today a vital part of the Jewish community.

JEWISH FAMILY SERVICE

The following was reported in the *Lynn Daily Evening Item* in 1954:

> *The Jewish Social Service Agency Auxiliary (now Jewish Family Service of the North Shore) constitutes one of those extremely rare phenomena in*

which the child gives birth to the parent. In the winter of 1897, a group of inspired young Jewish women, intent upon alleviating the financial and emotional difficulties with which so many Lynn Jewish families were suffering, organized the Ladies Aid Society.

Today, under the able leadership of Executive Director Jon Firger, Jewish Family Service of the North Shore continues its mission to provide services—financial, counseling, adoption, in-home assistance and a kosher food pantry, to name a few—to community members from babies to seniors.

The future of Salem's shrinking Jewish community is impossible to predict. Today's community is more diverse than ever: many of today's Jewish adults are unaffiliated, not religious or intermarried. Many young people leave home for work opportunities, pulling up roots and planting them somewhere else. The synagogue is no longer *the* center of Jewish life, and the local Jewish businesses that serviced their neighbors are gone for the most part. So we can say with some certainty that the next fifty to one hundred years will be different from the past. We may look back on the Jewish experience in Salem not only with nostalgia but also with envy for the sense of community that gave Jewish life such vibrancy.

Written by Judy Axelrod Arnold and Judy Simon Remis, with special thanks to Honorable Samuel Zoll.

BEVERLY

Originally part of Salem, the city of Beverly, on the coast twenty-two miles north of Boston between Salem and Gloucester, was incorporated in 1668 and, along with rival Marblehead, claims to be the birthplace of the U.S. Navy. A diverse community, Beverly is home to high-tech businesses, blue-collar residential neighborhoods, middle-class suburban subdivisions and the affluent areas of Prides Crossing and Beverly Farms.

TEMPLE B'NAI ABRAHAM AND BEVERLY'S JEWISH HISTORY

Elaine Israelsohn

Jews passed through Beverly on their way to somewhere else. That changed in 1898 with the arrival of Nicholas and Bessie Zelinsky, who settled into their home at 71 Park Street. They were followed by Barnet and Annie Albert, whose child, Samuel, was born January 24, 1899, at their home at 61 Park Street. This was the beginning of a permanent Jewish community in Beverly.

At first, Shabbat and holiday services were held in various homes. As the number of families grew, community gatherings were held in Burnham Hall on Cabot Street from 1905 to 1908. Outgrowing Burnham Hall, the community found a larger space in the rear of the Wood Building on Rantoul Street. It was here that the "local Hebrew colony," as the press called us, formed a congregation known as the Sons of Abraham, incorporated by the Commonwealth of Massachusetts on June 4, 1908.

Before 1912 there were three Jewish congregations in Beverly—Sons of Abraham, Sons of Israel and Sons of Abraham and Isaac. After land was purchased and a new synagogue was built on Bow Street, the three congregations merged under the name Congregation Sons of Abraham and Isaac. The synagogue became known as the "Bow Street Shul," the first structure built in Beverly by Jews for Jews.

In 1930, a Hebrew Community Center was erected as an annex to the synagogue. New organizations—a Sisterhood group, the Hebrew Civil League, the Beverly Lodge of B'nai B'rith and AZA for teenage boys—joined the Ladies Aid Society and B'rith Abraham Lodge already in existence. Jewish religious and social life revolved around the shul and the community center—breakfasts, suppers, plays (including *Fanny the Matchmaker*), dances and a variety of fundraisers. The year 1937 saw the arrival of Rabbi Meyer Finkelstein, the Jewish community's first ordained rabbi, who was the spiritual leader of the synagogue for eight years. A new charter in 1939 shortened the name of the synagogue from Sons of Abraham and Isaac to Sons of Abraham. In 1942, the congregation purchased land on Cole Street for a Jewish cemetery. (Prior to this, Beverly's Jews were buried in Danvers in the cemetery maintained by Salem's Congregation Sons of Jacob.) After a five-year struggle and a court case, the Sons of Abraham Cemetery was finally dedicated on July 27, 1947.

During the years of World War II, about seventy Beverly Jews served in the military. The community maintained contact with these GIs by a newsletter, *Vos Hert Tsach* ("What's New" in Yiddish). The newsletter, published in 1943 and 1944 and edited by Sons of Abraham members Moses Simon, Jack Share and Irene (Ginsberg) Jacobs, contained news of local Jewish communities, as well as letters sent by Beverly servicemen from around the globe. In 1946, Jewish War Veterans Post 486 Goldberg-Zassman was established, honoring Isadore Goldberg, who died in a Japanese prison camp in the Philippines, and Harry Zassman, lost at sea when the USS *Franklin* sank.

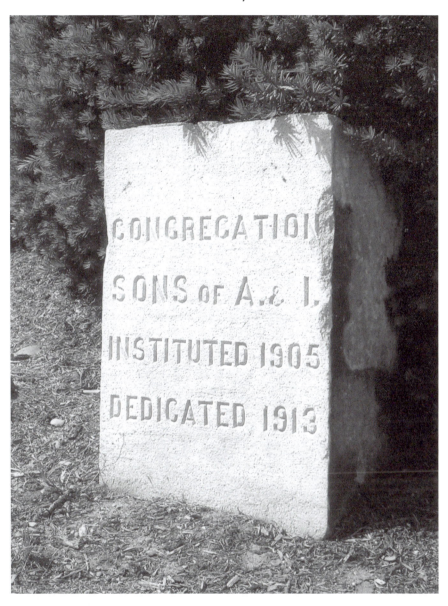

Congregations Sons of Abraham and Isaac was established in 1905, and the building at 37 Bow Street, Beverly, was dedicated in 1913. This cornerstone of that building was relocated to Temple B'nai Abraham in the 1960s.

On February 19, 1945, a fire of suspicious origin destroyed much of the synagogue and community center buildings. Not to be daunted by this tragedy, the community rebuilt a combination synagogue–community center that was dedicated in 1947. In 1948, the board voted that men and women would be allowed to sit together at services. The new sanctuary had even been rebuilt without a balcony!

When there is standing room only for the High Holidays and inadequate space for the Hebrew School, the time has come to add on to the existing structure or to move. In 1960, land was purchased on East Lothrop Street, and under the leadership of Jack Weisman and his dedicated committee, money was raised for a new synagogue. Groundbreaking took place in May 1961. Rabbi Irwin K. Botwinick led the congregation in both the old and new sanctuaries from 1959 to 1970. The celebratory dedication of the new synagogue was held in 1962, accompanied by another change of name from Congregation Sons of Abraham to Temple B'nai Abraham. The old Bow Street Shul was sold to the Knights of Columbus.

Until the 1970s, the synagogue could not be called egalitarian. Although women played important roles as fundraisers and organizers of social and

Groundbreaking at Temple B'nai Abraham on Lothrop Street, Beverly, on May 7, 1961. *Left to right*: Max Rubinstein, Building Fund Chairman Max Toll, Alvin Toltz, Youth Director Jacob Sterman (with shovel), Rabbi Erwin Botwinick, President of the Congregation Jack Wiseman, Building Chairman Alfred Freeman, President of the Sisterhood Mrs. Roslyn Tanzer, construction superintendent Ray Rust, contractor Richard Walsh and Vice-President of the Congregation Lewis Axelrod.

cultural programs, men made all the administrative decisions. That changed a bit as women were given the right to vote at congregational meetings. Once that hurdle was surmounted, it was decided that women could hold office on the board of directors and executive board. As the Conservative movement became more egalitarian, women stood on the bimah, read from the Torah and were counted as members of a minyan. Girls' Bat Mitzvahs, which usually took place on Friday nights, could be held on Saturday mornings, when the Torah is read. Finally, and emblematic of change, in 1975 a woman, Bette Siegel, was elected president of the congregation. The next years saw a succession of spiritual leaders—Rabbis Barton Leftin, Louis Zivic, Jeffrey Foust, David Abramson, Cantor Aaron Marcus and Jacob Rosner.

Over the years, as Temple B'nai Abraham has reached out to interfaith couples, more and more have become members, presently constituting

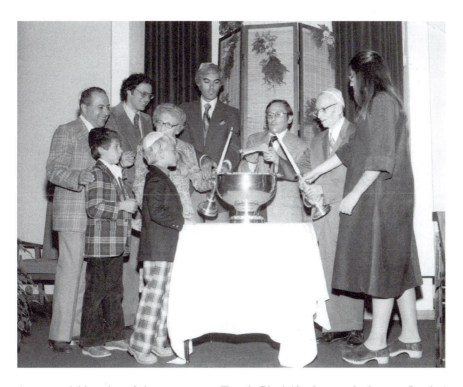

A ceremonial burning of the mortgage at Temple B'nai Abraham took place on October 22, 1978. *First row*: Daniel Skolnick, Mark Rosen and Joy Kaufman. *Second row*: David Blatt and Lizzie Katz. *Third row*: Rabbi B. Leftin, Barry Rosen, George Casper, and President Max Edelstein.

Temple B'nai Abraham's "Minyan-aires." *Front*: Al Tartakoff and Harry Silverstein. *Back*: Abe Kaufman, Jack Israelsohn and Saul Axelrod.

about a third of its membership. In 2007, the interior of the building was renovated, resulting in a beautiful sanctuary, social hall and lobby.

In 2008, Temple B'nai Abraham celebrated its 100th anniversary with a gala weekend of activities and programs. Under the spiritual leadership of Rabbi Steven Rubinstein, President Martin Greenstein and Executive Director Deborah Schutzman Vozzella, the congregation enters its second century with renewed vigor along with a commitment to continue the vital spiritual, educational and cultural programming that has been its legacy.

Elaine Israelsohn is a longtime member of Temple B'nai Abraham, a Conservative congregation located on East Lothrop Street. The previous section is based on a history she wrote and published in the commemorative book for the 100th anniversary of the synagogue in 2008.

Beverly

A Brief Remembrance

The following, a guided walk down the main streets of Beverly, was provided for the Temple B'nai Abraham archives by Ralph Edelstein.

When I arrived in Beverly around 1937 at the age of nine, a great many Jewish residents worked and carried on their professions within the city and the downtown areas. Residences tended to be located away from the two main streets but mostly within walking distance. Most of the Jewish businessmen and professionals were located on Cabot and Rantoul Streets and a few in the adjoining areas. A few were employed by the United Show Machinery Corporation and by smaller businesses, but very few worked out of town. A two- or more car family was a rarity at that time, and shopping was mainly downtown.

Both the Bow Street Shul and the barely competing Orthodox shul on Beckford Street were in the downtown area. The members of the two shuls were not generally socially compatible, and among a few individuals the incompatibility led to some enmity and even litigation long after the Beckford Street Shul had burned down. The Bow Street Shul in the late 1930s and early 1940s tended toward Orthodoxy with the women segregated to the upstairs balcony, but it was not long before some of the women took to infiltrating the so-called male area, and integration quickly followed. However, it did remain an all-male sort of good old boys' institution as far as temple administration and ritual was concerned, with the women limited to collateral organizations such as Sisterhood, Hadassah and ORT. It would not be until the Lothrop Street Temple was built in the 1960s that the women were fully accepted as participants in the ritual life and administrative leadership of the temple.

If we were to take a walk down Rantoul and Cabot Streets in the 1940s and 1950s, we would encounter a plethora of Jewish businesses as well as some Jewish professionals. Starting just beyond the Beverly-Salem Bridge at the confluence of Cabot and Rantoul Streets and heading up Rantoul, we would pass Murray Goldfield's auto cushions shop on our left, and as we looked across the street we would see the large brick building housing the Cantor family's American Seltzer Bottling Company. Proceeding up to Edwards Street just past the Edwards School, we would find the Gershaw Grocery store on our right. Proceeding a little farther we would encounter Marv Rich's used car lot on our right and would probably see Marv schmoozing with potential customers while smoking his huge cigar.

Continuing past the post office and crossing Broadway, we would see Eddie Sterman's variety store, which soon became Borah Yoffa's "Borah's," which retains the name but not the ownership to the present day. Looking to our left down Broadway, we would see the Sterman Cab Company autos at the train station.

If we could see beyond the tracks to River Street, we would see a large brick building housing the B. Fred Yoffa Wholesale Grocery Company. Crossing Rantoul Street from Borah's, we would find the Winer Brothers Hardware Store operated by Ben, Jack and Louis Winer, and Sam Weinberg's Quality Cleaners. A few doors down would be the Jake Sterman Pawn Shop. A few more steps to Wallis Street and looking to our left we would see the steam coming out of the large building housing the Saratoga Popcorn Factory, owned by the Tolls and the Dollins. Crossing over to the right side of Rantoul Street again, we proceed to Federal Street, where we cross and come to my father's National "D" Store, owned by Max and Rose Edelstein. If we were to go inside, we would experience an immediate sensory feast: the wonderful smell of the half-sour pickle barrel and the visual charms of corned beef, lox and cream cheese in the glass refrigerated cases and piles of bagels and bulkies in the bread bin up front. In the Depression years, we would likely have encountered customers ordering a quarter pound of cream cheese, an eighth of a pound of lox or three or four slices of corned beef. The non-Jewish world, for the most part, had not yet discovered the joys of Jewish deli, bagels and bulkies, so there would not be many customers who were not Jewish.

On the other side of the National "D" was the Chinese laundry and upstairs were both Italian and Jewish residents. On one of the mailboxes you would see the name Eddie Duchin, the famous pianist who had apparently resided here in the early '30s. If we proceeded a few more steps we would come to the Gordon Shoe Store, which unfortunately would be destroyed by fire in a couple of years. Next to Gordon we would find Jacob Rubenstein's machine shop in which at least a few of his five sons were employed. (This was prior to the large Utility Metal Company they would build on Elliott Street.)

If we were to turn the corner on Pond Street, we would find Willie (Velvel) Liebowitz's kosher meat market, where Willie's brother Yossel was the *shohet*. If we were to enter, we most likely would find Willie in a contentious argument with some housewife who was complaining about the fat on the cut of meat or the poundage provided by Willie's scale. Willie would be

adamantly shouting in a combination of Yiddish and English that God "in Himmel" had made the meat, not him, and that if you question the scale, you come climb up and I'll weigh you and you will see it is "ricktik" (correct). The customer was never right and would never win the argument. Willie, originally a member of the Beckford Street Shul, later became an honored member of Temple B'nai Abraham and one of the Torah covers memorializes him.

Continuing on Rantoul Street, crossing Pond Street, we would soon come to Seligman Liquor Store, operated by "Mr. Seligman" and his two sons. Across the street would be the Collier Woodworking Shop, one of the few businesses operated by a non-Beverly resident. A few doors past Seligman's we would come to Mac Weinberg's hardware store. At this point, we will cross over and continue on Rantoul Street and come to a gasoline pump right on the sidewalk. For some reason unknown to us, Mr. Chiplowitz, who lived in the house adjoining the sidewalk, was the operator of the lonely pump, and if you found him at home you could fill your tank for a few cents on the gallon. (Mr. Chiplowitz's son Irving Chipman would become a well-known court reporter in the '60s.) A little farther down we would come to a real gas station on the corner of Elliott Street, which was operated by Bernie Goldberg, who would become a large heating oil dealer and marry Barbara Goldberg, resulting in a family real estate dynasty.

Just across Elliott Street, we would find the Katz tailor shop and, on the corner of Rantoul, the Davis Drug Store, which would much later become the Flaxer Drug Store. You would find this to be a wonderful place for an ice cream soda and also a place where a lot of young men could be found heading to the rear of the store, where Sam Davis would dispense his under-the-counter male supplies. From Davis Drug we would proceed to the intersection of Cabot Street and turn left. A short way down we would find Max Baker's pub. Across the street we would find Joe Greenstein's bicycle shop, and we would probably find Joe repairing a bike. Continuing on, we would pass Max Barron's tailor shop, and then crossing Beckford Street we would come to J.L. Simon's insurance office. From here, we would pass the Kransberg residence on the right and have to go all the way to North Beverly, where we would find Joe Katz's pharmacy. Joe was adventurous enough to forego the downtown for the wilds of North Beverly. Joe's son David would later continue the operation of the pharmacy.

If we were now to go back and begin walking up Cabot Street from the Beverly-Salem Bridge, we would come upon Harry Katz's shoemaker

shop, and when we cross over, there would be the Berman Liquor store, which years later became Sandy Berman's famous jazz club. A few doors down would be Bernstein's grocery store near Fayette Street. Crossing back and continuing past Railroad Avenue, we would come to Barney's Liquor Store and Alcon's Department Store. Around the corner from Alcon's on Washington Street would be Pranikoff Barber Shop. A little off course there was Doctor Sam Albert on Hale Street and Harold Racow's pharmacy. At Quincy Park would be Sid Altshuler, and on Corning Street would be Jack Weisman's Jules Goudreau lumber mill. Jack would be the leader of the temple building committee on Lothrop Street.

Continuing on Cabot Street, past Washington, we would come to attorney Abe Glovsky's office above the bank. Two of Abe's sons, Henry and Bert, would join the firm, and Henry would become a state senator. Across the street from Abe's office, we would find Maurice Cutler, the dentist, another of the

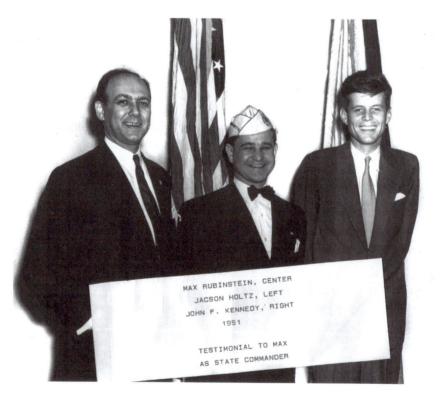

MAX RUBINSTEIN, CENTER
JACSON HOLTZ, LEFT
JOHN F. KENNEDY, RIGHT
1951

TESTIMONIAL TO MAX
AS STATE COMMANDER

In 1951, Max Rubinstein was honored as state commander of the Massachusetts chapter of the Jewish War Veterans of America and is pictured with then congressman John F. Kennedy.

few nonresidents. Continuing on down Cabot Street past Federal Street, we would find attorney Ben Lederman's office over the National Bank. Crossing back we would find Dr. Margolis's optometrist's office, and continuing on past Dane Street, we would come to Sam Kransberg's furniture store. Again crossing back and passing Elliott Street, we will come to the offices of Dr. Grush and a few doors down and a few years later, Dr. Brodsky.

In those days, the leaders of the temple (shul) were all well-known men in the community; there was little separation between the shul and the Jewish community. The immediate prewar leaders returned from World War II in the mid-1940s and continued to function in the traditional manner. The turning point was in the early 1960s, when the new temple was built on Lothrop Street. The younger generations included new Beverlyites from Roxbury, Dorchester, Mattapan, Chelsea, Somerville, Malden, Medford, Everett and beyond. They became the new leaders and began welcoming women's participation in ritual and administration. The new Temple B'nai Abraham was the symbol of change and from that time has embodied the modern Beverly Jewish community.

How Jewish Life Used to Be

As told by Joseph Rubenstein to the Beverly Hebrew School Students, October 8, 1992

My family came to Beverly in 1906. My father was employed by a company that was located in South Boston, and when the company moved to Beverly he moved his family here. My memories of the Jewish community in Beverly go back to the time when I was four or five years old. I started Hebrew School before I went to elementary public school. After public school we would go to Hebrew School one hour a night, Monday through Thursday. We also went to Saturday morning services, and we had a junior congregation. The temple at that time had about one hundred members.

It was a very friendly community. We didn't have TV and radios were electric powered. We didn't have USY, but we had AZA, which was part of B'nai B'rith. We had a group called the Judean League, and that gave us the opportunity to meet kids in other communities. Our parents used to drive us back and forth. The Bar Mitzvahs are a lot fancier today than they were then. After our Bar Mitzvahs we would go into the social hall and have just a little dash of food, nothing too exorbitant. We didn't have any bowling parties, and we didn't have any skating rinks or any of those things, but we got the basic training that we should have gotten.

Oh, yes, there was anti-Semitism. When I went to Hebrew School, I lived on Federal Street and I used to have to go to the Hebrew School on Bow Street. When I walked up Rantoul Street from Federal Street to go to the temple, I had to go through an Italian section and they always picked on us, and I used to get into stone fights. But then after a while we got to know each other and that all stopped. When we got into junior high school and high school, we became very good friends. You were looked at a bit differently because you were Jewish. But we didn't let that deter us from doing anything that we wanted to do. We were always friendly with the gentiles. We were highly respected in this community.

My first memory of temple? Well it goes back to the early '20s, when I first went to Hebrew School, which was downstairs in the basement of the synagogue on Bow Street. I went to Hebrew School until the time I was fifteen years old. I became a Bar Mitzvah there. The men used to sit downstairs and the women used to sit upstairs. But that all changed during the war. We had a big fire, which was set, and it burned down the temple and we built a new one. We didn't build a balcony, so the men and women started to sit together. We had a reciprocal program with the congregation in Salem, and we used to walk from our temple in Beverly to their temple in Salem at least once a month, and they would walk from their temple to our temple. We would exchange our friendship that way. We are still very good friends with a lot of those people.

We had a community center that was built next to the synagogue after the fire. We used to hang out there. We used to have programs there every evening. We had game equipment, and kids of different ages used to come with different groups. At one time we even tried to start a Boy Scout troop, a Jewish Boy Scout troop. Everything took place at the community center.

When the temple moved from Bow Street to Lothrop Street, I thought it was super! Because it gave us an opportunity to enlarge our community, to

do more for the kids. We had larger classrooms; we had a bigger sanctuary. It was a nice-looking building, and it meant a lot to the people of Beverly to see the progress that we had been making. My father was one of the founding fathers of the temple and was also a president of the temple. My brother Phil was president in the '40s and my brother Max was president in the '60s. I was president of the temple in 1979. So we have all been very heavily involved.

We were not a very big community, we were only about one hundred families during World War II, and there were over sixty Jewish fellows and women from the city of Beverly who went into the service. We have a cemetery here in the city of Beverly, and at the main entrance of the cemetery there are two markers for two Jewish boys from Beverly who lost their lives in the war. One of them died in the Bataan death march at Corregidor in the Philippines, and the other died when his ship was sunk at sea. When we came home, we formed our own Jewish War Veterans organization. We used to run big minstrel shows on Bow Street that were sold-out on Saturday and Sunday nights. It was a very active organization. We had a Ladies Auxiliary, and they used to spend a lot of time going to veterans' hospitals running bingo parties for all the veterans who were in the hospitals. Some of them would never come out of the hospital, they were so badly banged up.

The first rabbi that I remember was back in the '40s. Rabbi Meyer Finklestein was the first rabbi that we ever hired as a permanent rabbi at the synagogue on Bow Street. I had mixed emotions when the women were first considered a part of the minyan because I came from an Orthodox background. But it didn't take long for me to be convinced because women are very important in family life and in Judaism, and they should be so honored. I did not eat anything that was not kosher until I was eighteen years old. I left home for a while, and I had to eat and I didn't know where to go. I couldn't find any kosher restaurants. But we are living in a different society. It's important to hang on to our tradition; that's what it is.

Our Jewish community is one of the few Jewish communities in the entire North Shore that is completely integrated. When I say "completely integrated," I mean in Jewish life—a full life from birth to death. We have a cemetery here in the city of Beverly that belongs to the temple. The name of the cemetery is Congregation Sons of Abraham Cemetery. It's in a nice location. It was a struggle to get it. At the time that our fathers tried to get a permit to have a cemetery, they had to go before the city fathers, the board of aldermen, to get a permit. Every time they brought it up, it seemed as

though the city fathers kept on putting roadblocks in front of them so we couldn't get the permit. Until finally the Supreme Court here in the state of Massachusetts came back to our board of aldermen and said, "You will issue a permit to these people…You have no right to prevent them from having a cemetery for their people." So we have the cemetery.

Remember your heritage. You should never, ever deny that you are Jewish, because if you do, people will take advantage of you. But if you speak up to them, they will respect you. And this has been proven hundreds and hundreds of times. That's important. You have a heritage. Hang on to it.

AFTERWORD

Although not large enough to have a chapter in this book, the Jewish presence in the towns of Saugus, Lynnfield, Danvers and Cape Ann deserve mention. Despite their small numbers, the Jews of these towns have a long history of involvement in the spiritual, cultural and charitable life of the overall Jewish community.

Saugus is a small town sandwiched between the larger cities of Revere to its south, Lynn to its north and Malden to its west. The center of Jewish life in Saugus has been Congregation Ahavas Sholom, located at 343 Central Street. Built in 1925, the white wooden building remains open today, over eighty years later. The sanctuary is not unlike the interiors of other shuls built in the early 1900s. It is a wooden structure with upholstered chairs on the bimah, an impressive chandelier, beautiful arched windows and a balcony originally built for female worshippers.

While many shuls of its vintage were dissolved and disbanded years ago, Ahavas Sholom was kept from extinction by its small but devoted membership and the leadership of the synagogue. Founders and long-term members include the Yanofsky, Berg, Sherman, Shapiro, Cashman, London, Carp, Saunders, Gibbs, Werlin and Pinciss families. Harry London, who moved to Saugus in 1914, was president well into his nineties. As Bette Keva of the *Jewish Journal* reported in 1998:

> London makes sure repairs are done, pipes don't freeze and bushes outside are trimmed. "I had the rug put down in the center of the shul," said the retired dairy farmer in his thick New England accent. "Without it, it's like walking into a barn. Dave Posner and some of the old members built the

Congregation Ahavas Sholom, 343 Central Street, Saugus. The shul, built in 1925, is still an active synagogue serving the Jewish population of Saugus.

sukkey [sukkoh] *out back. It was a good sukkey, but it didn't last. I had to haul it to the dump." Explaining his devotion he stated, "I'm into it because the Saugonians need a shul, and what good is a Jew unless he has a shul to go to, so let's keep it going."*

Keeping it going was not always easy. The "little shul," as it is referred to, celebrated its seventy-fifth anniversary in 2000. At that time, the congregation met to consider dissolution and disposal of its assets. Instead of dissolution, the congregation, led by President London and Cantor Dr. Joseph Golner, voted to continue.

Today, the shul not only is open for the High Holidays but also conducts a Friday night Sabbath service once a month led by Michael Simons of Burlington. William Appel serves as Temple president. Since 2000, the shul's membership has increased from twenty-five people to one hundred families (mostly adults). Its Sisterhood raised money to replace the building's roof and back stairs and obtained used seats to refurbish the sanctuary. The congregation is now a member of the Saugus Clergy Association. In 2006, it hosted the first ever public Passover Seder, attracting over 160 guests.

Congregation Ahavas Sholom will continue to play a major role in maintaining the fabric of the Saugus Jewish community for many years to come.

Saugus had several Jewish businesses and professionals. Lou Sherman ran Sherman's Market in Cliftondale Square, which became very popular when it opened because it was the first supermarket in the area. David Hurwitz and Sam Stahler were owner pharmacists in the center of Saugus. Across the street was a dental practice began by Donald A. Roos, DMD, in 1938 at 311 Central Street. Dr. Roos's son-in-law, James A. Hazlett, DDS, joined him in his dental practice. Dr. Hazlett is still in active practice today.

Several Jewish physicians moved to Saugus in the late 1930s and early 1940s, established practices and became affiliated with Saugus General Hospital, among them Drs. Joseph Arbetter, J. Stanley Carp, Arthur Chernoff and A. Alfred Weiner.

The Gibbs Oil Company had its origins in Saugus. Martha Gibbs Rose shares the following reminiscence:

My Dad and his siblings grew up in Weymouth where they went to high school. I think the family first moved to Saugus because my "Zayde" had a job at a shoe factory in Lynn. After he was blinded in an industrial accident, he collected and sold rags and junk from a horse and wagon. When he needed to make change, he would hold out his hand with the contents of his pocket and, when criticized for not being careful enough with strangers, he would answer that "anyone who would steal from a blind man needs the money more than I do." The Gibbs opened a business on Newburyport Turnpike [Route 1], sometime in the late '20s or early '30s. They started on the site of my grandparents' home where my grandmother ran a farm stand. Today, York Ford is located there. A friend of my Dad and uncle suggested that the site was a natural to put in a gas pipe, and the rest is history. At the time of my parents' engagement in 1935, the Gibbs brothers were already considered among the most eligible bachelors of the Boston-area Jewish community. During World War II, when rubber was among the materials rationed, my father and uncle drove along the turnpike and gathered up abandoned flat tires, which they took to have retreaded and then sold. One of Dad's favorite stories was about the day when a strange truck driver showed up and requested that my Dad bill a falsely inflated amount to "the boss" and they would split the difference. My Dad declined the offer, and it turned

out the driver was, in fact, the boss, who then ordered his whole fleet of
Boston-to-Portland truckers to fill up at the Gibbs station.

Lynnfield's Jews have typically affiliated with congregations in neighboring Lynn, Wakefield and Peabody, particularly Temple Ner Tamid and Temple Beth Shalom in West Peabody. For many years, Lynnfield has had an active Lynnfield-Saugus Chapter of Hadassah.

Danvers, a postwar bedroom community, attracted many Jewish families affiliated with Peabody, Beverly and Gloucester synagogues. In 1958, a small group formed the Danvers Jewish Couples Club. While primarily a social organization, the group's members contributed their efforts for the betterment of the community at large, including the donation of books to the Danvers Public Library and the establishment of an annual scholarship at Danvers High School. The group was active into the 1980s and enjoyed a long association with the Holy Trinity Methodist Church, which made its kitchen and meeting rooms available for joint Brotherhood meetings, dances and bagel and lox breakfasts. The group also held family picnics at Endicott Park.

In 1983, at its twenty-fifth anniversary, 100 people attended a get-together at the Commodore Restaurant in Beverly. At that time, it was estimated that there were 150 Jewish families in Danvers, and 45 couples were members of the club. Paul and Jackie Newman became presidents, Steve and Natalie Kolodny vice-presidents, Howie and Melissa Tuttman treasurers, Toby and Ben Gary corresponding secretaries and Lee and Leslie Tapper recreation secretaries.

Among the first Jewish businesses in Danvers was Ira Toyota, a successful dealership on Route 114 purchased by Ira Rosenberg in 1975. Ira and his son, David, expanded the business as Ira Motor Group until they sold it in 2000.

The Jewish community of Cape Ann includes the city of Gloucester and towns of Manchester-by-the-Sea, Essex and Rockport. *The Jewish Community of Cape Ann: An Oral History*, by Sarah V. Dunlap, published in 1998, is an excellent resource. The absence of materials on Cape Ann is not intended to diminish the important contributions that the Jews of the Cape Ann communities have made in creating and maintaining a vibrant presence. This is evident in the aftermath of a devastating fire that resulted in the loss of its synagogue, Congregation Ahavat Achim in Gloucester. The congregation is planning a new synagogue, rising from the ashes on its original site in 2010 or 2011.

ACKNOWLEDGEMENTS

This book could not have been created without the research, writing and editing of historical society members Edye C. Baker, Helaine R. Hazlett, Judy and Mark Arnold, Judy S. Remis and, most especially, Barbara Vinick, whose eye for detail and editorial experience was invaluable.

We also gratefully thank and acknowledge the contributions of:

The *Jewish Journal*, Publisher Barbara Schneider and Editor Bette Keva, and we also appreciated its impressive archival materials and photographs; the Jewish Federation of the North Shore and Executive Director Liz Donnenfeld, President Robert Salter and Janie Secatore; the board of directors, President Martin Greenstein, Executive Director Deborah Schultzman Vozzella, Elaine Israelsohn, Ralph Edelstein and the late Joseph Rubinstein of Temple B'nai Abraham of Beverly; the board of directors of Congregation Sons of Israel, including Paul Ordman, Justin Ordman, Irving Sacks, the late M. Irving Herbster and Avrom J. Herbster and Milton T. Zorch; the late Nathan Gass, Dr. Stephen Mostov, the Honorable Samuel Zoll, Barbara Golen, Maureen Appel and William Appel of Temple Ahavas Achim in Saugus; the board of directors, Executive Director Deborah Hallett and the late Dr. Richard A. Winer of the Jewish Historical Society of the North Shore; Cindy Tittlebaum of the Danvers Jewish Couples Club, Bernice Kazis, Elaine Bakal and Zelda Kaplan; Sylvia Belkin, Louis Gallo, Reference Librarian at Swampscott Public Library Sandy Moltz, Barbara Kantor, Herb Goldberg, Bea Paul, Phyllis Sagan, Larry Alexander, George Shube, Lawrence Habin, Ann Kemelman, Alberta Lipson, Ina Hoffman, Dr. George S. Freedman, Nelson Dionne, Sharon Ferman, Ruth Kemelman Rooks, Martin "Bozie" Goldman, Barbara Shapiro Isaacson, Martha Gibbs

ACKNOWLEDGEMENTS

Rose, Richard Gibbs, Sylvia Cohen Berman, Jean Sherman, Gerald and Sara Posner and Ethel Sinofsky.

Photographs, unless otherwise noted, were provided through the courtesy of the Jewish Historical Society of the North Shore, *Jewish Journal Boston North* and the Jewish Federation of the North Shore.

I also thank Dottie Payne, who painstakingly prepared the manuscript and who could (sometimes) read my handwriting.

A special thanks goes to JHSNS vice-president Cliff Garber for his help with the photographs that appear in this book.

I owe much to my wife, Donna, for letting me spread research materials all over the house for several months.

ABOUT THE
AUTHORS/EDITORS

This book could not have been written without cowriters and society board members Edye Comins Baker, Helaine Roos Hazlett, Judy Simon Remis and Judy Axelrod Arnold.

Alan S. Pierce currently serves as president of the Jewish Historical Society of the North Shore, located in Salem, Massachusetts.

Alan is an attorney, board member of Temple B'nai Abraham of Beverly, Massachusetts, a member of Congregation Sons of Israel of Peabody, Massachusetts, and serves on the Jewish Federation of the North Shore Board of Directors.

Pierce and his longtime friend, the late Avrom J. Herbster, prepared an earlier book, *The Jewish Community of the North Shore* (Charleston, SC: Arcadia Publishing), in 2003.

Barbara Tolpin Vinick, board member of the Jewish Historical Society of the North Shore, performed the edits. A sociologist and board member of Kulanu ("All of Us") and the North American Family Institute, she edited "Esther's Legacy: Purim Around the World" and "Today I am a Woman: Bat Mitzvah Around the World" at Brandeis University. Without her input and expertise the finished produced would have been greatly diminished.